WATERCOLOR OPTIONS

RAY LOOS

WATERCOLOR OPTIONS

North Light Publishers

Published by North Light, an imprint of Writer's Digest Books,
9933 Alliance Road, Cincinnati, Ohio 45242.

Manufactured in Singapore
First Printing 1985

Library of Congress Cataloging in Publication Data

Loos, Ray, 1919-
 Watercolor options.

 Includes index.
 1. Watercolor painting—Technique. I. Title.
II. Title: Water color options.
ND2420.L66 1985 751.42'2 84-27227
 ISBN 0-89134-115-3

dedication

To my patient, and understanding wife Dianne, who, for a full year has put aside her own painting career to spend countless hours typing and retyping from my handwritten scrawl. Without her support and confidence, it would not have been possible to produce this book.

acknowledgments

My grateful appreciation to my friend Edgar A. Whitney, whose incomparable teaching introduced me to the challenging world of watercolor many years ago; to Fritz Henning, for his invaluable assistance in editing this book; to Don Getz, from whom I learned the watercolor-on-gesso methods and to my good friend and fellow watercolorist, Jack Hessler, for his photographic expertise; and to my many students who, throughout the years, have asked: "When are you going to write *your* book?"

contents

introduction

Many books dealing in watercolor painting have been written with only the artist-author's singular style and technique illustrated throughout the text. This is understandable. But you may not wish to paint his or her way. It is my intention to suggest and illustrate other options available to those serious painters who are, as yet, undecided on the directions in which their talents and abilities should take them in the future.

There is no easy way. Many painters have embarked on a painting career relatively late in their lives and have not had the opportunity, nor the reason, to learn the design-basics or the drawing skills that are so necessary in painting. My purpose is to simplify these basics in order to provide the watercolorist with a more confident as well as positive attitude when he or she approaches a painting problem.

From the beginning, desire and dedication must be present along with the understanding that nothing worthwhile is accomplished overnight. The road to successful painting may be strewn with errors, both of commis-sion and omission. These errors, however, serve a useful service, for by experiencing them we learn and adjust; constantly gaining knowledge and understanding on the way. It must be pointed out that understanding and appreciation of what we are doing develops faster than our ability. It is this fact that drives us onward as we try to close the gap between our taste and our ability. Remember: *good* paintings are the results of *good* painting habits.

Your decision as to the right style to follow is sometimes suggested by the subject itself. I recommend working from a pre-planned value sketch. Change and move objects and shapes. Alter size relationships. This freedom is the enjoyment of painting! This is the creative mind at work. Don't put restrictions on yourself. Enjoy this freedom of expression. After completing a painting, step back and examine it closely. Did you paint it "because that's the way it was"? Or, more importantly, "because that's the way I interpreted it"? Far too many artists paint what they see, but fail to see what they paint.

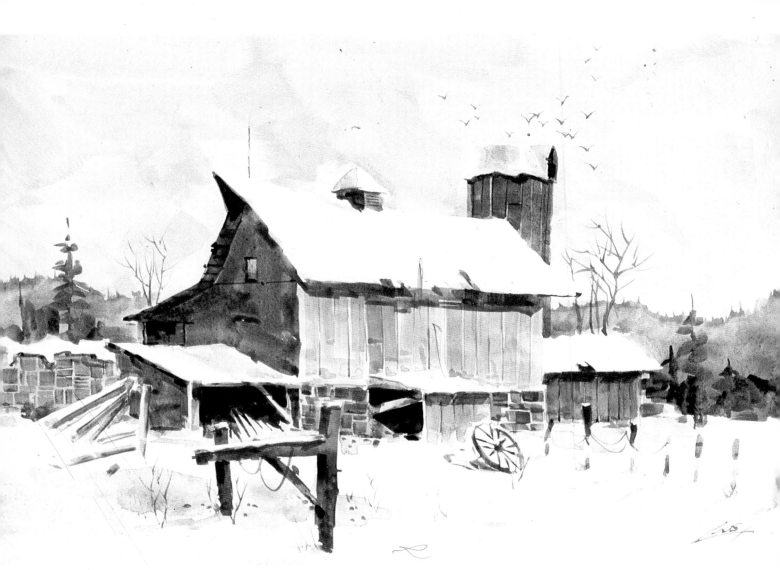

Winter Quarters—*22 x 15 inches,* collection of the artist.
A softer texture is obtained by using hot-press Arches paper.

Your thinking must be flexible and creative. Can you think abstractly? Impressionistically? Realistically? And can you pursue that sort of thinking throughout the painting period? Combining any of these styles will destroy the unity of the work. Unity is one of the most important principles of design: Unity of color, direction, theme, shapes, and values act to pull the work together. A lack of unity is one of the many pitfalls an artist may find. But with dedication and applica-tion of the basic rules, improvement will occur. An instructor can teach you many things, but your own development comes from experience.

I sincerely hope that with the material and information contained in this book that you can find the help you need to think about the many paths you may be able to follow. Be patient. (Impatience *is* your worst enemy.) Expertise will come. Perhaps not tomorrow, but it will come with time and effort.

Beauty in the Rough—*22 x 15 inches,* collection of the artist.

I found this subject on Maine's Vinalhaven Island during a summer workshop. The setting provided an interesting interplay of textures, colors and subject matter; i.e. the daisies (nature) and the weather-beaten old barrel (man-made).

Since I wanted to include more detail, I decided to use the 140# hot-press Arches paper. To make the paper more workable I sponged off the surface, minimizing the puddling and crawling that occurs on the sized dry paper. The use of the hot-press paper provides the opportunity to edit the painting by lifting and repainting.

Textures and value variances can be altered almost at will.

The design is dominantly curvilinear with the grass, the barrel hoops and the daisies. Conflict is provided by the straight edges of the rocks and the barrel staves. The point of interest, the daisies, is emphasized by the strong value differences and the spots of color in the blossoms. I used maskoid to save the whites of the daisies, enabling me to paint the grass background with more sweeping strokes.

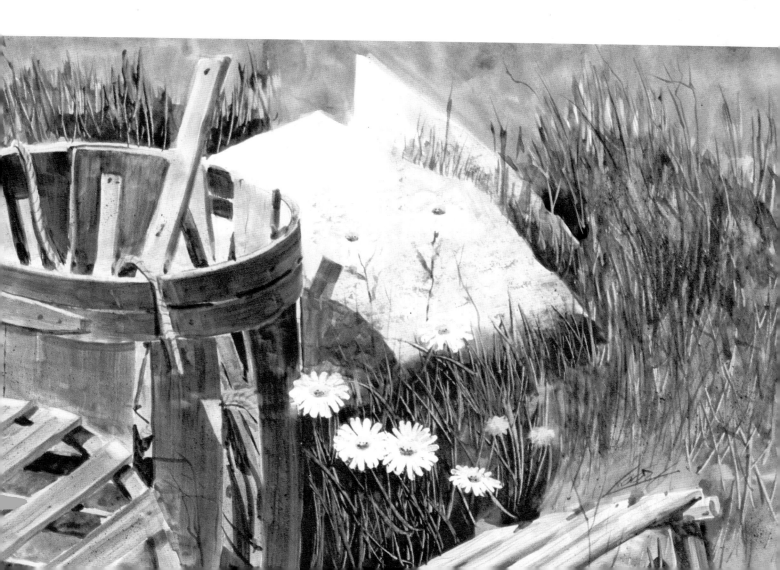

design principles

Certain principles have been formulated to help us in the search for good compositional effects in our painting. They provide a framework within which to transform a static form (the rectangle of the paper) into an eye-pleasing arrangement of colors, values, and shapes. A good shape, by definition, is: two different dimensions, oblique, and interlocking with the shapes around it. In the two-dimensional form of the rectangle of paper, we have to create the illusion of the third dimension—depth—by value, color, line, texture, and perspective.

In the eight principles illustrated on the next page—unity, conflict, dominance, repetition, balance, harmony, alternation, and gradation—you will discover that any or all of them will be helpful in the design of a good painting. Of all these principles, perhaps the most important is unity. Unity is that esthetic feeling of togetherness—the element that holds the work together. Without it, the design suffers from lack of cohesiveness.

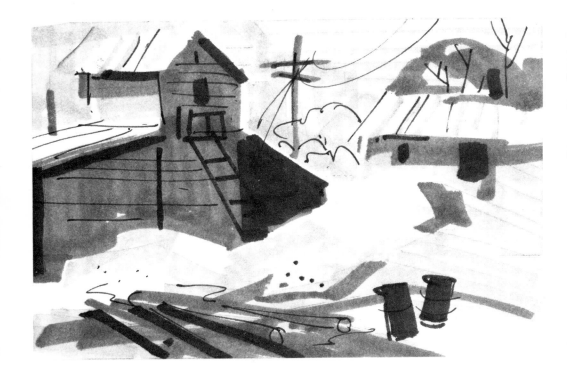

In the sketch above, note the large dark shape facing *into* the design. Oblique angles are dominant, while the curved lines offer minor conflict to all the straight lines. Perspective is accented by the angles of the obliques and the position of the buildings. In the sketch on the right, verticals are dominant, while the horizontals and curves serve as the conflict.

The illustrations on this page show the eight principles in very simple form. They each offer the basic construction required in every painting. Compare them to blueprints for a building. They show how to put down solid foundations that will last.

The observance of these principles will increase the possibility of producing a better painting since they are each basic for a sound, valid design.

unity
That quality of oneness obtained by color, value, direction, and line.

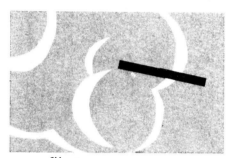

conflict
A minor opposition to the directional dominance.

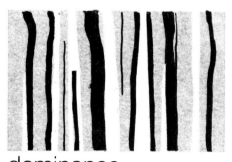

dominance
A direction of color emphasis that plays a major role in the design.

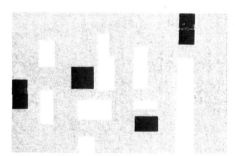

repetition
The repeating of a shape, form, value or color in different areas of the design.

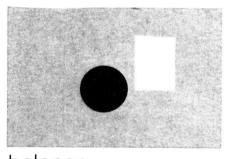

balance
An illusionary feeling of proper placement created by the shape, value and color relationships used in a composition.

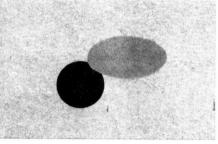

harmony
The relating of all elements—shapes, forms, lines, values and colors—so that everything works effectively in the picture.

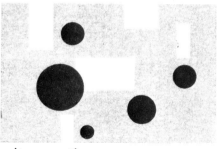

alternation
A form of repetition using different shapes in different sizes.

gradation
The diminuition of value or color from corner to corner, or top to bottom.

design elements

These seven elements are necessary in any painting to give the illusion of depth. Since you are endeavoring to express linear distance, they are the means of communicating the impression of perspective: taking the viewer's eye into the painting. Constant association with, and application of these design elements will become habit-forming. The same is true of the other design factors discussed in this chapter. Once you have mastered this you will be able to free your mind to concentrate on the esthetics of color and calligraphy.

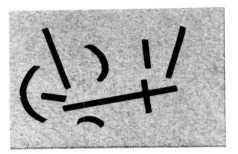

line
Either curved or straight—can include or exclude form.

color
Varying the color intensity can make elements recede or advance.

value
The lightness or darkness of a tone or color that controls the clarity of a painting.

texture
The suggestion of the appearance of a surface.

direction
The means, often linear, used to control where the viewer looks in a picture.

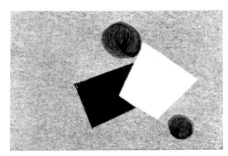

shape
The silhouette of a two-dimensional form or object in a picture. By their nature, shapes can suggest real objects relating to one another.

size
The relationship of the size of objects in a picture helps imply depth. This is most apparent when representational forms are suggested as in the sketch at right.

pattern schemes

The basic pattern schemes noted here offer good foundations for most paintings. The pattern scheme unifies the design, providing a background for the wise use of the design principles and design elements. Each plan offers a good starting point, minimizing the indecision that often occurs when you are faced with the sheet of blank paper.

A dark value in midtone.

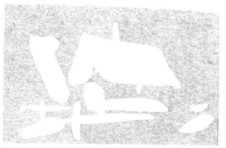

A light value in midtone.

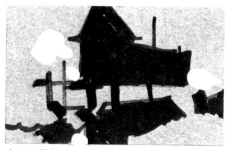

A small light area and a large dark one in midtone.

An overall pattern (checkerboard animation).

Gradation in any direction.

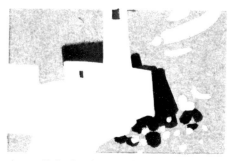

A small dark piece and large light in midtone.

The sketch illustrates small dark and large light areas in midtone.

15

paints

Manufacturers of transparent watercolors offer several grades of paints for the water-color artist. The paint quality is usually determined by the ingredients, how it is formulated, and how finely it is ground. The more expensive pigments are made of the finer materials, both natural and synthetic, and are more finely ground. The results are paints that are rich in texture, requiring less quantity to create the effects desired. My favorite professional-grade pigments are made by Holbein and Winsor-Newton, but I do not hesitate to use student-grade Liquitex if they meet my needs.

transparency

It is important to know your paint. Recognize the dye or staining colors, and know how to use them, as well as the sedimentary and earth colors which can be altered later if needed. In my palette, I carry the following pigments which have staining properties: thalo green and blue, Hooker's green light, new gamboge yellow, Prussian blue, and alizarin crimson. These are useful in building transparent washes, or they can be used as an overwash on a dry painting. (Overwashes can completely change the mood of a painting or the center of interest. I have "saved" many paintings using this method.)

opacity

The sedimentary or earth colors are of a granular nature. In the student-grade they leave an unwanted sediment on the paper when dry. In the finer grades, however, the sediment rarely occurs. The opaque colors offer the opportunity to "edit" a painting once it is dry because the pigment lays atop the paper, making it quite easy to lift off. These lifts can transform a dull area into a more exciting passage.

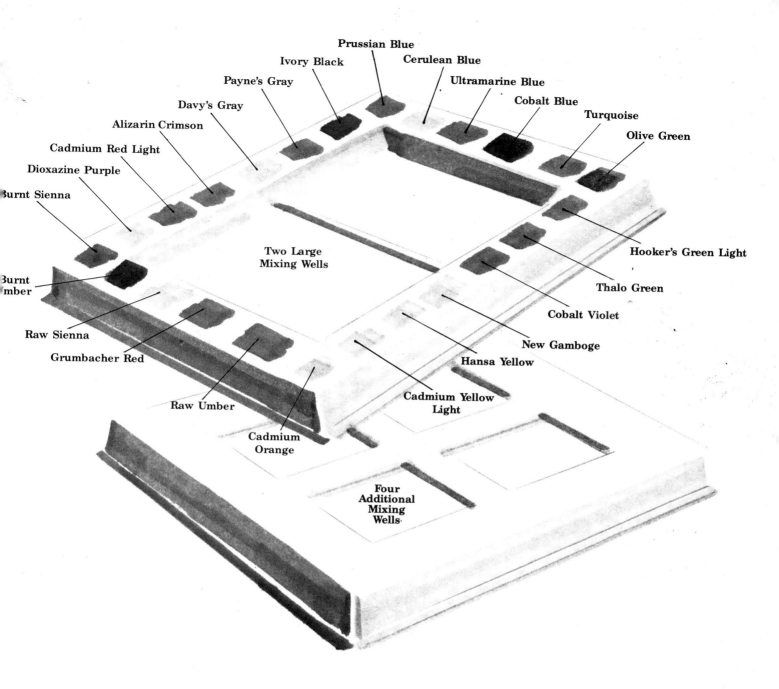

Prussian Blue
Ivory Black
Cerulean Blue
Payne's Gray
Ultramarine Blue
Davy's Gray
Cobalt Blue
Alizarin Crimson
Turquoise
Cadmium Red Light
Olive Green
Dioxazine Purple
Burnt Sienna
Two Large
Mixing Wells
Hooker's Green Light
Burnt Umber
Thalo Green
Raw Sienna
Cobalt Violet
Grumbacher Red
New Gamboge
Raw Umber
Hansa Yellow
Cadmium Orange
Cadmium Yellow Light
Four Additional Mixing Wells

palette

The plastic Robert E. Wood palette shown above is ideal for my method of painting. I usually paint "wet-in-wet", consequently I need a quantity of fresh, wet pigment available immediately. This palette is well designed for such use. It has 24 deep wells, large enough to accommodate my larger brushes. Each well holds three small tubes of paint, or two large #5 tubes. To maintain moistness, I spray water into each well before closing the cover. The mixing areas are quite large, two in the base, and four in the cover.

When traveling, I tightly cover and seal the wet pigment wells with a sheet of heavy-duty aluminum foil. This holds in the moisture and keeps the paints in their proper places and ready for use.

I arrange the palette with the warm colors to the left and cools to the right, as indicated in the sketch. Familiarity with the location of each color will become habit-forming and you'll find yourself instinctively reaching in the right direction for the desired pigment.

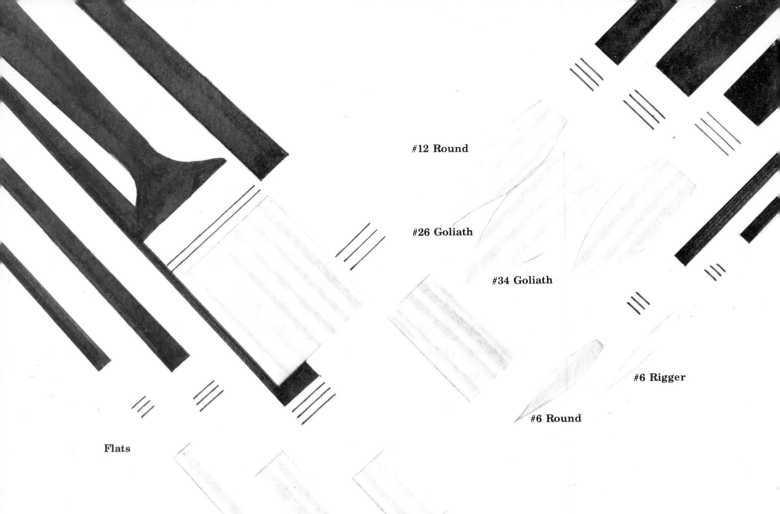

#12 Round

#26 Goliath

#34 Goliath

#6 Rigger

#6 Round

Flats

brushes

The selection of brushes is a personal choice. Over the years, I have become partial to the synthetics now available—both flats and rounds—some of which are illustrated above. They hold plenty of paint, come to a good point or flat chisel edge, have excellent spring, and are reasonably priced. I also use two sables, the #6 rigger (or striper) and a #6 round, which I have owned for years.

The large flats, the two-inch and the inch-and-a-half are used for laying in the initial washes. Fast, positive strokes can define immediately any large basic shapes. Using the larger brushes in the beginning eliminates the "hem-stitching" effect that often afflicts the novice. More than half of my paintings are executed with larger brushes. This helps to keep the patterns simple.

The large round brushes are useful in defining objects that are curvilinear in nature:

tree foliage, bushes, shrubs, and clouds, for example.

The rigger is used primarily for detail and calligraphy: the sweep of boat rigging, of electric or telephone lines, hanging ropes—all can be painted in a free-swinging manner. You'll find that turning the painting upside down allows for a more natural swing of the brush for these types of strokes.

paper

There are many fine papers available, and perhaps you already have a favorite. But for superb response, toughness with many tools, and for texture, the Arches paper from France answers all my needs. I use the cold and hot press 140 lb. paper, and for larger work, the 300 lb. cold-press which needs no stretching and stays flat when wet.

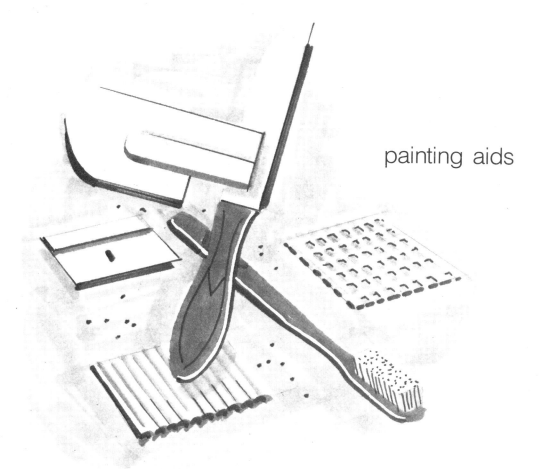

painting aids

There are many tools and materials you can use to complement your brushes. Some that I use are shown above. These can create special effects to "dress up" areas where needed. Such tools can be almost anything that can be dipped into pigment to make a mark on the paper. Either by printing, scraping or used as a stencil, an effect is produced that is entirely different from one you get with a brush. Overuse should be avoided, however, for there is no substitute for the fresh, spontaneous and crisp brush stroke.

kitchen paring knife

A dull knife can be used for scraping out small lines in wet pigment to create the effect of fences, posts, poles, rope, netting and many more small items. By dipping the point in wet pigment, fine lines can be drawn to indicate telephone or electrical wires, or used to emphasize the division lines in siding.

toothbrush

An excellent means for making small spatters where such effects are desired is achieved with a toothbrush. Direction is con-

trolled by dragging the paint-loaded bristles across the knife *toward* the painting.

single-edged razor blade

This is a useful tool on dry paper for scraping in "glitter" on sunlit water and accenting areas where a touch of white paper shows. It can also be used as a drawing instrument on wet or dry paper by dipping the tip into India ink, and dragging it over the paper to make fine lines. If you ink more of the edge and pull it to one side you can make broad, interesting and weighted strokes.

pot scraper

This kitchen helper is my favorite tool! In the "wet-in-wet" method, the pot scraper can move pigment in any direction, and by varying the pressure, values can be altered. It may be used as a printer by dipping the edge of the scraper into thick wet pigment and applying it to the paper. My favorite pot scraper is available from Fuller Brush; its edges are more rigid than others I've found.

example of tool use

razor blade and ink
Crisp, definite line work results from this combination. Caution—don't press too hard!

berry basket
Found in most supermarkets, it can be used in two ways—positively and negatively. Used positively as a printer, it indicates interesting and fancy fencework. When used negatively, it makes a great stencil for church windows.

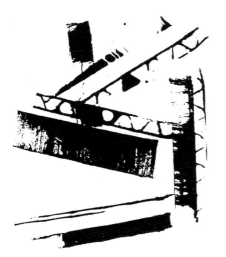

corrugated board
Printing with the flat edge indicates horizontal and vertical girders, and by removing the cardboard on one side it suggests a beautiful tin roof edge.

plastic screen
A handy tool for indicating fencing, nets, and trellis work. Print with light opaque paints for negative effects in dark areas.

pot scraper

Used as a squeegee, moving the paint to one side, still leaving the basic light color.

Used as a printer, line definition can be controlled for a strong linear effect.

By varying the pressure, value changes can be shown.

By dragging the paint into white paper, another texture is achieved.

kitchen knife

Dipping into the ink and dragging the blade to the side suggesting larger dark areas.

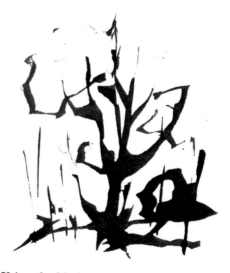

Using the blade as a point and turning it, gives interesting line effects.

the "wet" method

One of the first considerations in painting "wet-in-wet" is the type of paper to be used. It must be tough and durable and able to take punishment from your tools. Because of these specifications, I recommend 140 lb. Arches cold-press sheets in the 22×30 inch size (*not* the watercolor blocks).

Another consideration is the material upon which the paper is stretched. It must be lightweight, smooth and impervious to water. A sheet of clear acrylic (1) serves my needs best. It can be purchased from most building suppliers as "storm door replacement plastic". Or you may wish to utilize *Plexiglas* that is no longer usable for framing paintings. Cut 3/16 inch or 1/8 inch plastic sheet to a size 1/2 inch larger than the watercolor sheet. That is, the Imperial size sheet of Arches is 22×30 inches, thus the acrylic is cut to 23×31 inches. The half-sheet 22×15 inches would be cut to 23×16 inches. The 1/2 inch surplus is to allow enough space to clip the painting for flat drying.

(1) With the paper positioned on the sheet of acrylic, or other support, and with the watermark side down (the grain is smoother on this side), start soaking the paper with a good-sized *natural* sponge—*not* synthetic.

(2) Scrub and soak until completely wet on this side. Lift the sheet and turn it over. Before re-setting the paper on the support, apply water to the plastic surface, then set the paper and scrub and soak the watermark side. Soak until every fiber of the paper is docile. This usually takes about five minutes. If lifted, the paper should fall back limply to the acrylic.

(3) Using a 6 inch window rubber squeegee or the wrung-out sponge, remove the excess water until the paper surface has a *matte* finish. Wipe away excess water from edges of acrylic before starting to paint to avoid bleed-

back. (You'll find following these steps will permit greater control of your washes).

Sketch the simple painting areas onto the wet paper with a 6B sketching pencil, indicating minimal details. These lines will partially dissipate as the painting dries.

(4) Using your value sketch as a guide, and with a 1½ inch flat brush, start putting in the midtones, leaving the light areas. Vary the values and colors in the midtones as you desire. The use of the large brush from the beginning through most of the painting prevents the fussiness so commonly seen with beginners. It also allows the important allocation of shapes vital to the basic design and composition of the work.

(5) Darks can be introduced using the same large 1½ inch brush. The darks are the key, for they dramatize the light and midtone areas leading to the point of interest. It is also important to vary the value and colors in these dark areas. As the paint dries, you'll find the colors will lessen in intensity since the wet paper absorbs the pigments. Consequently, it will be necessary to over-state throughout the painting. In other words, use strong color since the final effect will inevitably be less intense. For the same reason, paint with strong value differences in order to retain clarity.

During the drying process, ripples may develop in the paper which indicates that it is drying unevenly. To correct this problem, lift and re-wet the underside of the paper by wetting the acrylic sheet with the sponge.

After the basic pattern is established is the time to use some special tools to describe form in the larger areas. By dragging the spatula or scraper across the wet pigment, it is possible to indicate "up-planes"; the upper surfaces of objects that reflect the light. This also adds the third dimension to these areas.

(6) The smaller brushes, the #6 round and the rigger, can now be used to provide the icing on the cake—the calligraphy that creates the *lace*, the tying together of all the basic shapes. Here is your challenge: to unify all these elements into a fresh, spontaneous and sparkling watercolor.

The final step is to keep the paper flat. Clip all four corners with metal clips (prefer-ably non-rusting type) found in most stationery or hardware stores. In an emergency, spring-type clothes-pins can be used. As the paper dries, it shrinks and the clips keep it taut and flat. I have found this method easier and just as successful as the time-consuming paper-stretching methods used by many other artists.

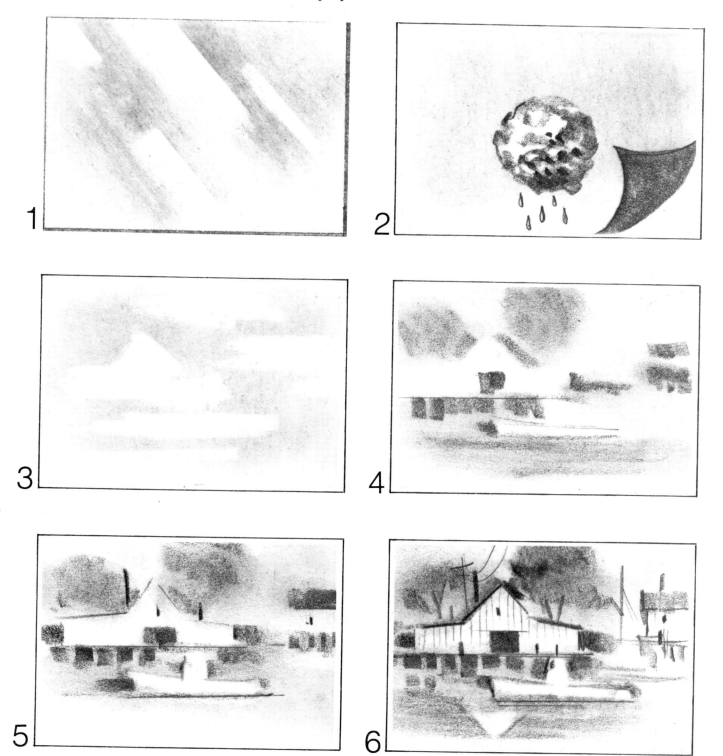

1

Make a viewfinder using a scrap of matboard. Cut an opening 5 ½ x 3 ¾ inches—this is the exact proportion of a half-sheet of Imperial size paper (30 x 22 inches).

2 Draw inside viewfinder with pencil for outside sketch dimensions. Rub rectangle with graphite-soaked cotton for midtone

3 Use a kneaded eraser to lift out the light areas. An interesting light shape is very important!

developing

the value sketch

4 With flat 6B sketching pencil, indicate dark areas.

5 Add more small dark areas to emphasize light and midtone shapes.

6 Add calligraphy and detail to finish.

subject I

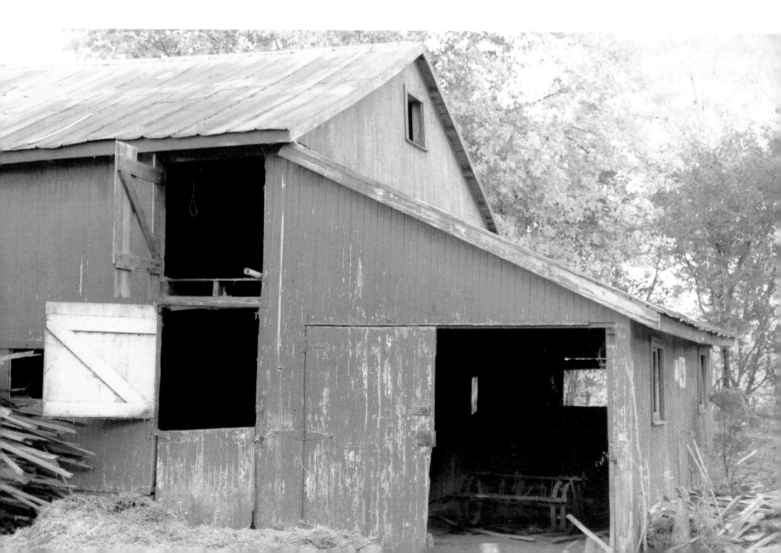

traditional

A representational or realistic approach to
watercolor, with detail in the drawing
and painting.

the subject analysis

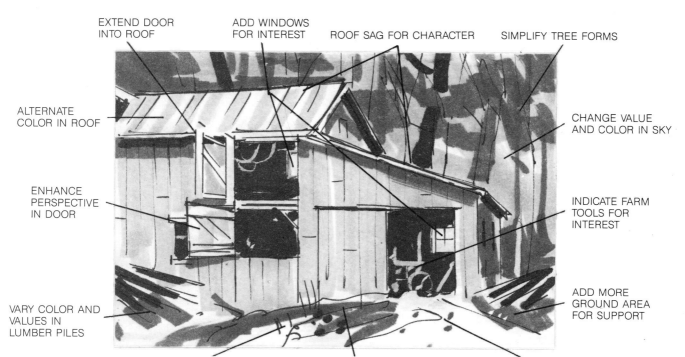

EXTEND DOOR INTO ROOF

ADD WINDOWS FOR INTEREST

ROOF SAG FOR CHARACTER

SIMPLIFY TREE FORMS

ALTERNATE COLOR IN ROOF

CHANGE VALUE AND COLOR IN SKY

ENHANCE PERSPECTIVE IN DOOR

INDICATE FARM TOOLS FOR INTEREST

VARY COLOR AND VALUES IN LUMBER PILES

ADD MORE GROUND AREA FOR SUPPORT

ALTER VALUES & COLORS IN FOREGROUND

CHANGE TEXTURE AT BARN/GROUND EDGE

ROAD FOR DIRECTIONAL INTEREST

what to look for . . . to leave in . . . or out

When on location or using a photograph, *squint* at the subject to isolate and identify value, size, and shape relationships. These relationships, and how you use them, are important to the overall design. If a better arrangement is suggested, don't hesitate to alter it. One problem stands out immediately in this photo—the size of the barn in relation to the size of the picture area. Reducing the barn's size allows better spacing (or air) around it, thus affording the opportunity to add more interest in the foreground and sky areas. The barn itself is composed of straight lines and presents a rather flat perspective. These are facts. But facts can be boring. So let's put a little sag in the roof and exagger-

ate the perspective a bit and, at the same time, suggest a more interesting base line to the barn. Examine the foliage. Think of it as form, only, then create its mass with areas of darker value.

Rarely does a photograph offer the complete solution to the design problem, therefore, it should be only used for details and general information. In black-and-white form, a photograph is helpful in value determination and relationships. However, caution must be exercised to use only photos taken by you, the artist, to maintain your artistic integrity, and to avoid copying another's work. (More thoughts on the use of photography in creative paintings are on page 132).

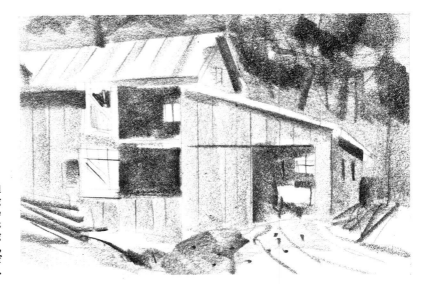

The use of the broad-tipped "carpenter-type" 6B sketching pencil is excellent for the value sketch. The flat wide part is great for the broad areas of barn siding and foliage, while the corner edge, used as a point, is ideal for roof edges, doors, and minor details.

the value sketch

The importance of the value sketch cannot be over-emphasized. It is my opinion that it constitutes a large percentage of a painting's success. Critical decisions can be evaluated, changes can be made, and a more positive attitude results from the confidence and surety of the sketch. And, from the standpoint of economy, it is much better to make alterations in the design using inexpensive sketch paper, than to try to change it subsequently on an expensive sheet of watercolor paper. It also eliminates the time-wasting effort of trying to make good things happen by painting directly on the sheet, while hunting and fishing for the right stroke or color. The latter is truly a gamble, with the odds against you.

The value sketch solves many problems in the basic design of the painting. Relationships and definition of sizes, values, directions and dominances can be resolved in the beginning. Allocation of the light shapes—the sky, roof, doors, and foreground—is created by the midtone shape of the barn. The location and size of the dark interior shapes help define and enhance the light and dark forms. Calligraphy and detailing add identification to the amorphous shapes.

Since you will be painting in a representational manner, care should be taken to sketch in the same way. It is important to retain the identity of the subject, which would suggest the use of more detail and careful drawing. Although design is of primary concern and function in any painting, it is important to realize the end result desired by most of us is a recognizable presentation of the subject. This, however, should not stifle the creative decisions that will improve that which the photograph could only suggest.

After wetting the paper, I sketched in the larger areas with a 6B sketching pencil. The midtones of sky and barn were then brushed in with the 1½ inch brush. Care was taken to leave the light areas open as possible. The pattern was established very quickly, with the creation of the interlocking shapes and the subtle directions of movement in the overall design.

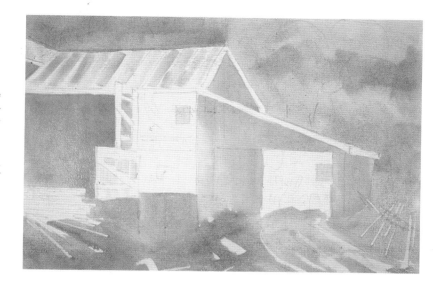

The darker tones were then introduced to enhance the lighter values. This will help in keeping the relationships more interesting. These strokes are bold and simple, again utilizing the large brush. This prevents me from becoming too "picky" too soon. Too often a painting can become overdone by using small strokes before the basic pattern is established.

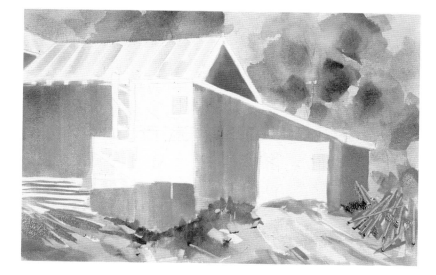

Now for the darks! Wise application of the dark values can make the basic design come to life. The darks develop the more definite shapes and overall relationships. Value differences are important, because they make the painting "read" from up close or across the room. The darks in the doorways give substance and depth to the structure. Now I am ready for the finishing touches, the calligraphy, to complete the painting.

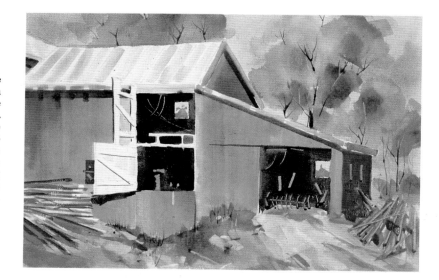

With the questions of value, shape and size resolved in the value sketch, we can now turn our attention to the actual painting to be rendered in the "wet-in-wet" method.

Color scheme becomes the first item of importance. Here, simplicity is the keynote. Just because there are 24 colors in the palette, is no reason to attempt to use them all. First, I decide on the color dominance: should it be warm or cool? If warm, as in the example, I will use a simplified palette of three basic warms and only one cool. Example: raw sienna, burnt sienna, cadmium yellow light, (the warms) and ultramarine blue. The use of these colors and the muted, or grayed-down, mixture of them helps to keep the color scheme more harmonious and unified. A wide range of warms and cools, lights and darks can be achieved from just these four colors. Avoid a half-warm, half-cool painting: It creates an equal—or static—color division.

This painting is dominantly warm—the warm reds in the barn plus the warm greens in the foreground. A slight color conflict is generated by the cool sky. Try to keep the forms clear and recognizable by using distinct value separation. This is especially important when working "wet-in-wet", since the moist paper tends to diffuse and blur the pigments.

Paint the form (the overall shape of the object), then the form description (value changes within the form to indicate light directions and shadows). Note the foliage, the foreground, the siding, the dark interiors and the piles of lumber at each end. These areas work together to create textures and interest in the painting. Adding spatter makes the foreground richer and more appealing.

the completed painting

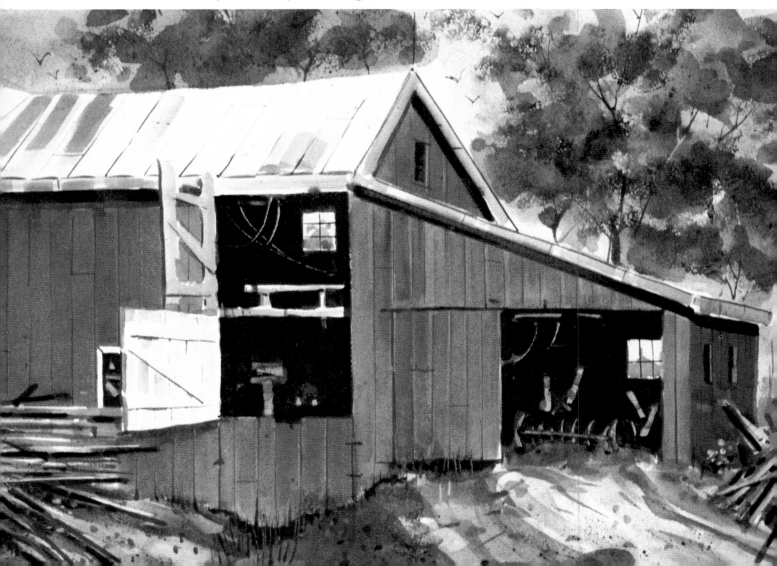

calligraphic

Painting with free-swinging brushwork; having a
spontaneous appearance. Subjects are slightly
distorted, simplified and almost caricatured.

the subject analysis

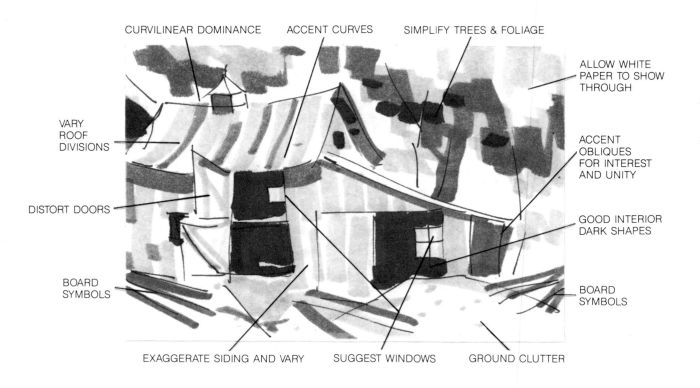

CURVILINEAR DOMINANCE ACCENT CURVES SIMPLIFY TREES & FOLIAGE

ALLOW WHITE PAPER TO SHOW THROUGH

VARY ROOF DIVISIONS

ACCENT OBLIQUES FOR INTEREST AND UNITY

DISTORT DOORS

GOOD INTERIOR DARK SHAPES

BOARD SYMBOLS

BOARD SYMBOLS

EXAGGERATE SIDING AND VARY SUGGEST WINDOWS GROUND CLUTTER

spontaneous . . . fresh . . . but disciplined

The calligraphic style, with its free-swinging brushwork, slightly distorted, simplified, almost caricatured subject treatment, is a challenge to your creative ability. To show the most with as few strokes as possible, to keep the fresh feeling, can really test the abilities of a painter. You must deliberately distort so the viewer knows you've exaggerated the subject—not just drawn it badly. It must look spontaneous and sparkling, requiring positive and sure brushwork.

A knowledge of basic drawing is necessary. You have to know both what the subject is, before you paint it, as what it is not. It is the ability to show this fine distinction that illustrates the skills of a creative painter.

This is a painting with many accents: the sweep of the roofline, the single stroke definition of the barn siding, the "kiss-off" of the foliage, and the lumber piles. Note how the roofline is indicated: rather than painted,

curved strokes are used to suggest the tin roof. Also, see how casually the ventilator is placed. This is a demonstration of not *what I paint*, but rather an example of what can be *left out* and still retain a fresh, exciting picture.

The "call-outs" around the sketch indicate a few of the more salient points so valuable in the treatment of the painting. Such considerations save time and allow you to be positive in the actual rendering.

Fresh color is a must, and it is important to avoid overpainting for this tends to dull the vibrancy of the color. Again, I emphasize the need for good planning in the value sketch. It is essential.

Symbolism plays an important part in this type of rendering again, calls for some creative thinking. Try to express yourself while you entertain and fascinate the viewer.

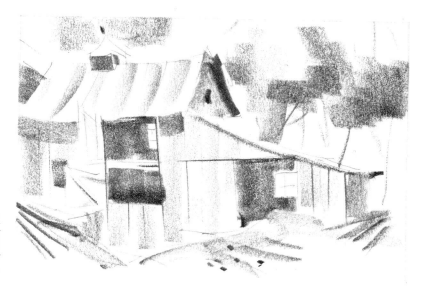

The broad-tipped 6B sketching pencil is ideal for indicating the sweeping fresh movements in a calligraphic rendering. The strokes will be similar to the actual brushwork.

the value sketch

The value sketch is my plan of attack for the subsequent painting, whether it be in the traditional, calligraphic, graphic, abstract, or gesso style. The values, shapes, and movement are all predetermined in the sketch. It provides me with the confidence I need to achieve a positive, free approach in the final painting.

The curvilinear dominance is accented by the straight lines in the barn siding, the doorways and other architectural elements. Directional lines take the viewer into the subject and the darks provide interest in the larger shapes.

The use of symbols—the simplification of an object to its barest recognizable form, (painting shorthand if you will)—is used throughout the sketch. Examples are the ventilator atop the barn, the piles of lumber on both sides of the building, and the slightly askew windows in the dark areas. It is the use of these various symbols that adds freshness and sparkle to the calligraphic style, and is one of the unifying factors in the sketch and later on the final painting. It gives the work the same degree of finish throughout. I repeat the curvilinear theme everywhere, accented by straight passages.

By indicating the sweep of shape and direction in the sketch, I find the spirit carries over into the painting. Experiment in the sketch, change and alter, erase, and resketch to your satisfaction. Then you will be ready to paint . . .

The completed work shows the discipline and resolve necessary in developing a fresh and spontaneous painting. The interplay of curves to straight lines, positive brush work, the dominant warm colors, complemented by cool foliage, all aid in the feeling of a positive reaction.

Note the variance in the widths and intensity of the barn siding, the suggestion of the curved roof, (a curve that is echoed in the bend in the tree trunk), all accented by the straight lines in the lumber piles and the foreground brush strokes.

The half-hidden, partly suggested farm tools in the dark open door add a touch of mystery and added interest in the dark interior. As you can see, the roof line is only implied; its position controlled by the curved strokes in the roof and the position of the ventilator. The windows are also indicated as both positive and negative forms.

The foliage is a combination of values of greens that merely suggest the actual feeling of leaves and tree limbs.

Spatter is added to create the effect of an untidy barnyard. This provides more variety in the foreground.

the completed painting

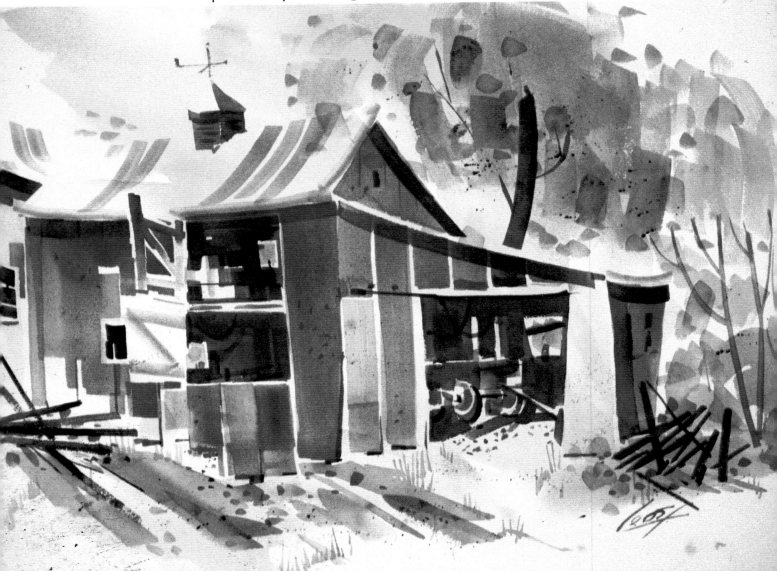

graphic

The use of flat forms throughout the painting
with no gradation or blending of value and color.

the subject analysis

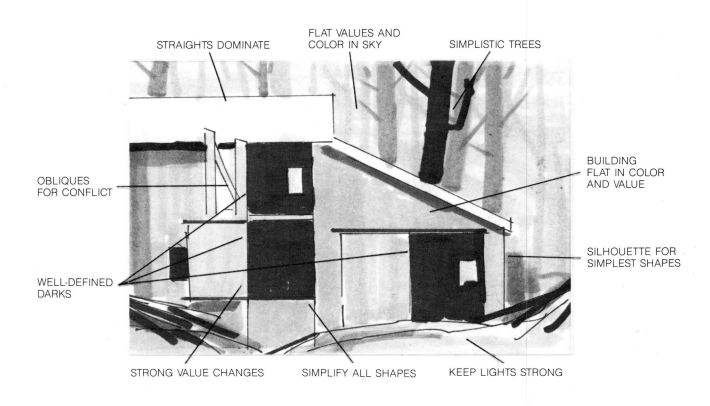

STRAIGHTS DOMINATE

FLAT VALUES AND COLOR IN SKY

SIMPLISTIC TREES

OBLIQUES FOR CONFLICT

BUILDING FLAT IN COLOR AND VALUE

WELL-DEFINED DARKS

SILHOUETTE FOR SIMPLEST SHAPES

STRONG VALUE CHANGES

SIMPLIFY ALL SHAPES

KEEP LIGHTS STRONG

think flat . . . think design

The graphic style requires a different approach from the traditional or representative style. A good design sense and an eye toward flat expressionism are helpful. To be able to two-dimensionalize the subject completely without subtle value or color gradations makes this another exciting style of painting.

As the callouts show in the above sketch, pre-planning the work is important. Definite value and color changes, and a strong design, combined with the small conflicts in the oblique, straight, and curved lines, can create a viable, yet subtle pattern.

The barn is almost in silhouette, composed of a series of flat value areas, with interest provided by the light windows breaking up the dark rectangles of the interior and doorways. The strong angle of the roof, leading obliquely to the right and down, is repeated in the slope of the snow in the foreground. The tree trunks serve as stabilizing foils for this movement. Also, the varying values and sizes in the woods provide a secondary interest.

Working with flat forms requires discipline. If you start to indicate form you begin to lose the graphic feeling.

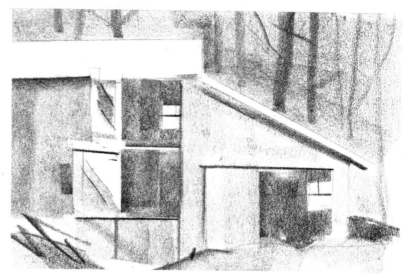

By varying the pressure, the flat, soft pencil is excellent for describing the variety of flat shapes and values. The point edge creates the necessary straight lines that help show movement in these values.

the value sketch

Time-saving pre-planning can make the difference between a good or bad result. It provides me with the groundwork necessary to follow through with a crisp, well-defined watercolor.

The value sketch can be altered or varied as you work through the painting. For example, if the value structure of the subject does not read clearly, strengthen one value against another. If it is not dark enough make it darker. Conversely, if it needs to be lighter, remove part of the value with a kneaded eraser. By the use of these additions or deletions you control the design.

Try to think of your picture from a sequential aspect. Midtones first, delineating the lights, then add the punch and interest of the darks. What I accomplish with the dark can affect the results to a high degree. Where I place the darks and their relationship to the lights and midtone can be decided at an early stage in the value sketch.

This is the end result of my pre-planning and thought: flat colors with no gradation, and a simple palette of reds, blues, pale greens and dark browns. Four parts cadmium red light, tempered with a touch of burnt sienna provided the barn color, while washes of cobalt blue formed the snowy foreground. The deep brown is a mixture of about one part cobalt and four parts burnt sienna. The trees and sky were painted in washes of olive green mixed with cobalt and grayed with Davy's gray.

Notice how the rather colorless background of tree shapes of different sizes and values enhances the strong color in the barn siding. This color is also emphasized by the dark in the doors and interiors. The windows, with the see-through effects, help break up the monotonous dark areas.

The flow of the blue shapes in the snow offers curvilinear conflict to the strong straight lines in the barn. Also the conflict of cool and warm colors adds visual interest.

Little definition is necessary in the shape of the barn other than to suggest divisions in the larger forms. Perspective is implied by the lineal directions in the foreground and the shape of the swinging door. The handling and the values in background trees and sky give an effect of distance in relationship to the foreground.

the completed painting

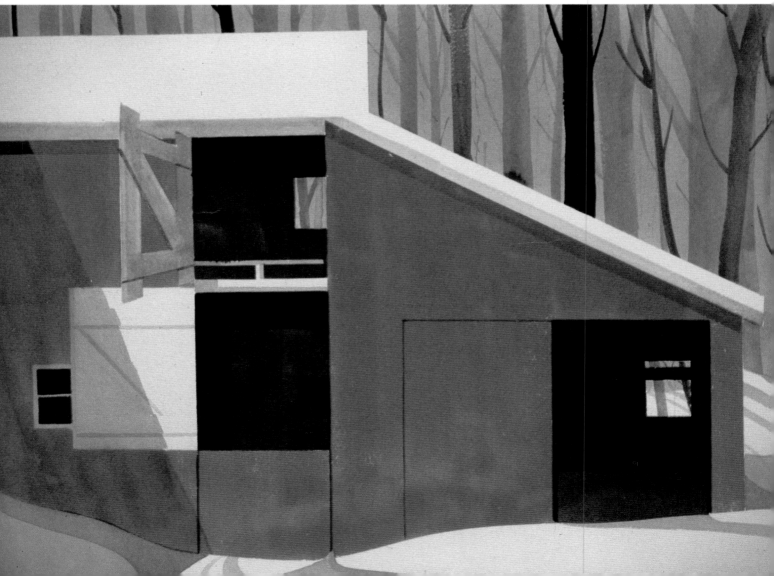

abstract

The altering of shapes, colors and overall appearance into unrealistic form, but retaining some subject identity.

the subject analysis

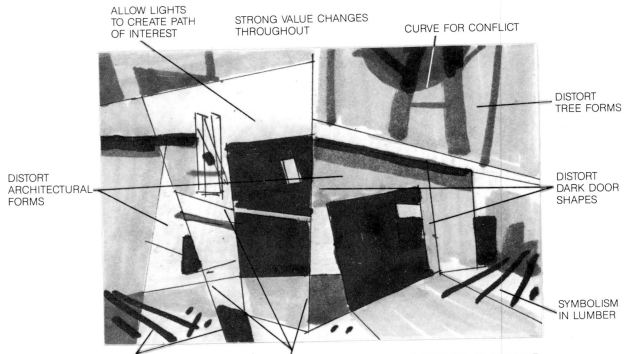

ALLOW LIGHTS TO CREATE PATH OF INTEREST

STRONG VALUE CHANGES THROUGHOUT

CURVE FOR CONFLICT

DISTORT TREE FORMS

DISTORT ARCHITECTURAL FORMS

DISTORT DARK DOOR SHAPES

SYMBOLISM IN LUMBER

SYMBOLISM IN FOREGROUND MARKS

LINES OF DIVISION

REPEAT OBLIQUE THEME THROUGHOUT

for those who see beyond . . .

If you have acquired the necessary skills to paint in the academic or realistic styles, then the abstract approach is worth trying. It may open whole new avenues and add greatly to your repertoire. Let's consider what it means:

The dictionary defines abstract painting as an intellectual approach in which the affective content depends solely on intrinsic form. It is an art form on which the emphasis is placed on the arrangement of forms, lines, colors, etc. to produce a desired effect . . .

Referring to the sketch above, notice how all the shapes are altered and distorted almost to the point of non-recognition. However, in the overall view, the subject is still recognizable. In truth, abstracting is just

another design problem. It is a matter of uniting simplified shapes into a pleasing arrangement of darks, lights and middle values.

With a combination of strong lines in opposition to each other—horizontal, vertical and oblique—along with many solid-valued, angular shapes, you can create a lot of visual excitement. And that is what we're after: a feeling of movement and interest. Although some of the shapes are exaggerated, the overall effect still carries a sense of the subject. It is amazing how few clues the viewer requires to accept distortion as believable and quite real.

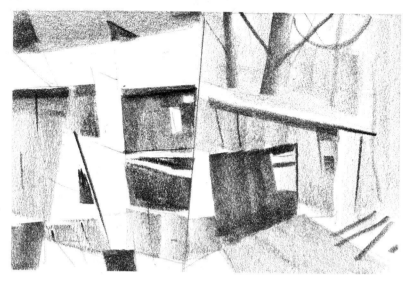

Definition of abstract shapes are accomplished more easily in the value sketch. The distorted shapes with their value changes can be evaluated more completely in the smaller form of the sketch.

the value sketch

There are many ways to accomplish the abstract and this is just one of many approaches. The subdivision of space is a great place to start and may key you in the direction you may wish to take.

Concentrate on the interplay of one form against the others. In this, how you use the values is important. Arrange the placement of the shapes to maximize clarity—the dark window against the white roof, the door (white) against the interior, and the main door forming a good readable shape against the red barn siding. These shapes, with all the varying diagonal lines and opposing angles, create an interesting overall design.

Details should be treated from an abstract point of view—as in the distorted window shapes, the lumber piles and the trees in the background. Being too representational will lessen the effectiveness of the whole painting.

Don't be afraid to try. Just bear in mind that a sound and valid design structure is the backbone of any work of art, be it representational, abstract, impressionist or non-objective.

At a larger scale the image becomes clearer and more understandable. The reds hold together as a shape, the blues and grays unite as a unit, the whites create a sparkle, while the darks pull all these elements together into a structured whole.

The smaller, angular shapes in the trees, lumber, doors and hanging ropes are accents that decorate the basic large forms.

Note the changes in form, value and color in the large shapes by reversing color and value where a divisional line occurs, as in the strong slanted verticals center and left-of-center. This creates better relationships of size, value and color in the doors, windows and roof.

Sharp changes of direction in the roof line, in the doors and ground forms offer variety and interest and aids in developing pleasing size relationships between the larger and smaller shapes.

the completed painting

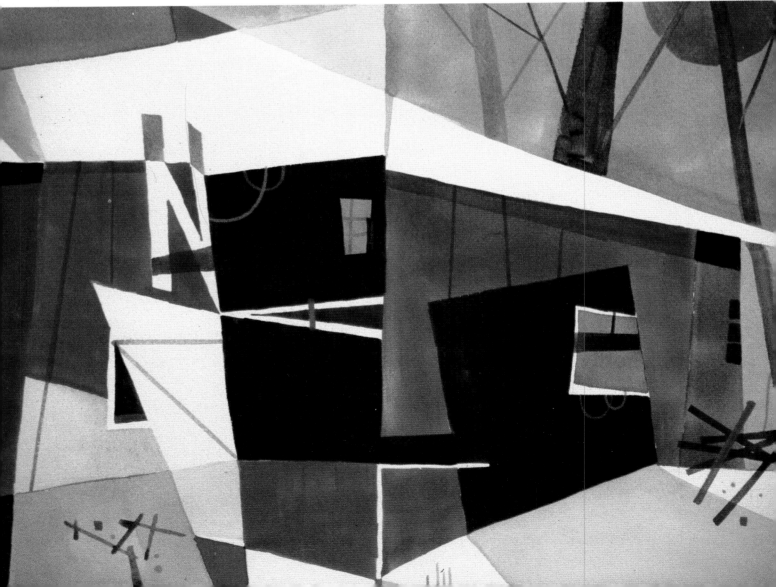

on gesso

Painting with heavy thick watercolor pigments
on gesso coated paper.

the subject analysis

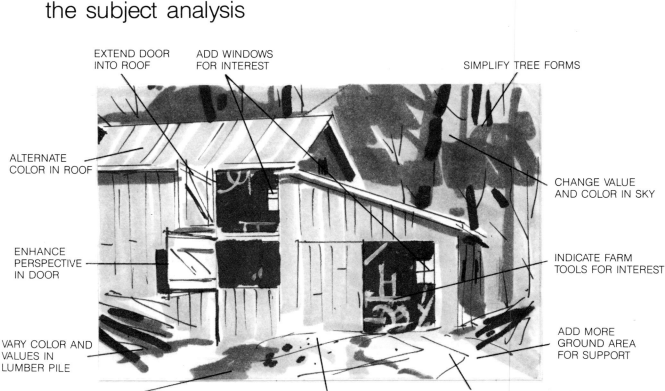

EXTEND DOOR INTO ROOF

ADD WINDOWS FOR INTEREST

SIMPLIFY TREE FORMS

ALTERNATE COLOR IN ROOF

CHANGE VALUE AND COLOR IN SKY

ENHANCE PERSPECTIVE IN DOOR

INDICATE FARM TOOLS FOR INTEREST

VARY COLOR AND VALUES IN LUMBER PILE

ADD MORE GROUND AREA FOR SUPPORT

ALTER VALUES & COLORS IN FOREGROUND

CHANGE TEXTURE AT BARN/GROUND EDGE

ROAD FOR DIRECTIONAL INTEREST

a more detailed approach

We'll start from basically the same subject analysis as in the traditional style. The main difference in the two approaches is in the execution and rendering. Watercolor on gesso is quite different from painting on regular paper.

As far as composing the work is concerned, it is as important as ever to consider the various design problems.

Everything begins with preparing the surface. I've found it's possible to gesso many types of paper, from various watercolor stocks (you can use the backs of not-too-successful paintings), to assorted boards (mat, backing, illustration, mount, foamcore, etc.). For this painting, however, I am using a paper called "Hypro" made by Grumbacher. It comes with a linen finish on one side, backed by a plain blotter-like surface. I use the linen side because I like the texture. In the finished work

it has much the pebbly look of canvas. One of the advantages of Hypro is that it does not shrink or buckle when covered with gesso. But in order to have a firm painting base, it must be taped or stapled to a sturdy backing of wood, masonite or pressed fiberboard.

First, I cover the paper with one coat of gesso, right from the can, and let it dry for about an hour. I sketch the subject on the dry paper with a 2H pencil. This allows easy erasing of unwanted lines. When starting to paint you'll find the gessoed surface repels the pigment which will crawl and bead. This can be frustrating, but the process provides some unique textures that are unlike regular watercolor effects. The problem of surface resistance can be overcome by constantly re-applying the pigment in a thicker consistency. It takes lots of brushing to blend and soften the edges.

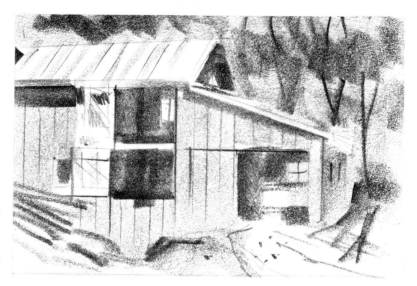

By varying the stroke pressure of the sketching pencil, subtle value changes in the large areas are easily managed. These pencil strokes are similar to the large strokes of the flat brush in the subsequent painting.

the value sketch

I start the design with the same interest and purpose as in the traditional method with the aim toward more detail and definition. It is necessary to decide where the detailed areas will be most effective and what kind of importance should be given to them. The foreground usually shows a greater amount of detail. Therefore, I plan this area carefully.

When working on a gesso surface values tend to be darker and more intense, because of the necessity to use larger amounts of pig-ment. Don't worry. The procedure is flexible and mobile. Also, if you are not satisfied with an area, you can use a small sponge to wipe out the pigment to the almost pure white of the surface. Because of the waterproof nature of gesso, the paint simply lies on the surface and can be easily removed.

Painting on gesso can be an irritating experience, but determination and perseverance prove to me the extra effort is worthwhile.

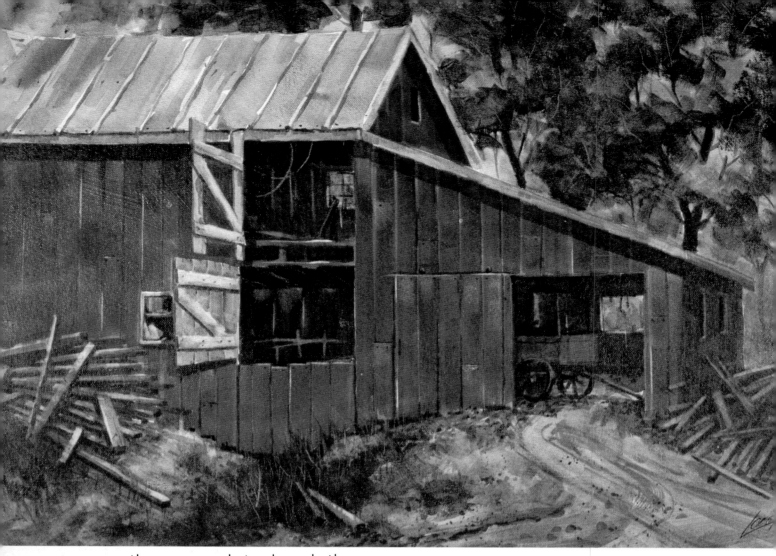

the completed painting

You will notice in the final result that the picture resembles an acrylic or oil painting. This is largely due to the texture of the linen finish paper showing through the pigment which creats an unwatercolorlike surface.

There is little sense of urgency in the gesso method: changes and alterations are fairly simple. This give me confidence and a sense of control seldom matched in other mediums or methods of painting.

One of the many advantages is that it remains workable. As already mentioned, if an area offends me, I wipe it out and repaint. Another important facet is the ability to lift off undesired areas of paint. The piles of lumber and the barn siding were painted as a dark shape. Then, with the edge of a damp ½ inch synthetic brush, the lighter tones of

the boards and the edges of the siding, were lifted out. The result is a more detailed description of these items. The red wagon and the lights in the interior were also lifted out. Later, the wagon was repainted red.

Now, for the disadvantages: Aside from the difficulty in getting the pigment onto the surface at the outset, it is important to remember the paint is not *in* the paper, but lying *on* the surface. Consequently, water can damage it. When the painting is completed and dry, a spraying of clear acrylic is necessary to "fix" it by binding the pigment to the paper. The acrylic coating also forms a waterproof barrier either of gloss or *matte* finish. Additions cannot be made after that application.

subject II

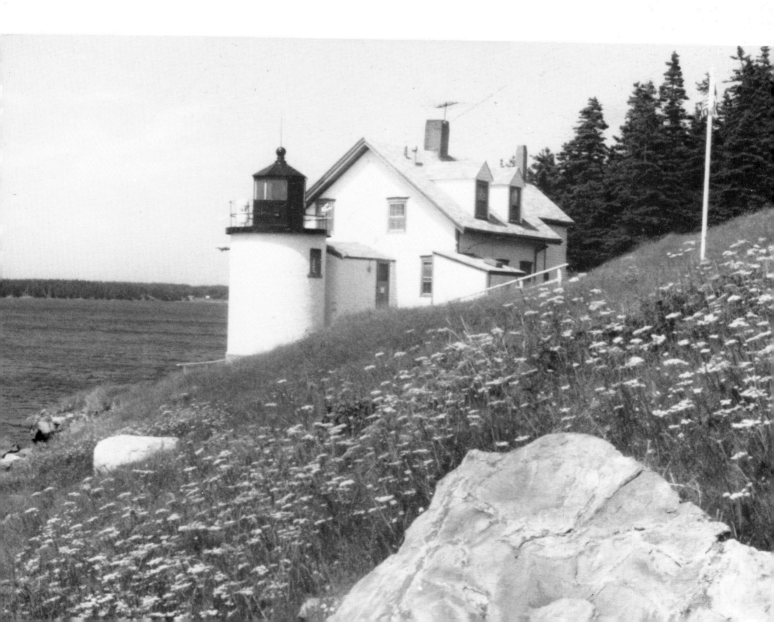

traditional

the subject analysis

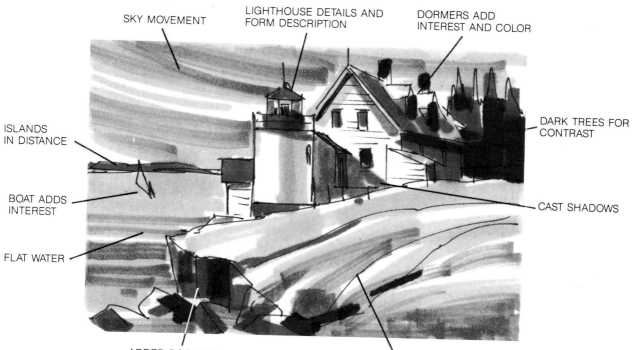

SKY MOVEMENT

LIGHTHOUSE DETAILS AND FORM DESCRIPTION

DORMERS ADD INTEREST AND COLOR

DARK TREES FOR CONTRAST

ISLANDS IN DISTANCE

BOAT ADDS INTEREST

FLAT WATER

CAST SHADOWS

ADDED ROCK SHAPES

GROUND MOVEMENT AND DIRECTION

look for good shapes, value changes . . .

In approaching this Brown's Head Lighthouse scene on Vinalhaven Island, Maine, I look for a number of things that would express the essence of the subject. In the first place, I like to place the light high in the composition to give the effect of looking up at it. Second, it seems logical to show the sea and the hazardous rock formations to explain why the lighthouse is there. In the photo there seems to be too much sea, and no rocks at all. The lighthouse is about centered and half hidden by the ground surface. For a good composition it will be necessary to take a few liberties and change what I don't like.

For instance, I know there is a small boat

shed hidden behind the light that would provide another touch of color. I decide to rearrange things and put the shed in the design. I like the rock formations at the base of the lighthouse, so I shift their location and add them to the foreground. The sailboat in the distance seems a good idea to relieve the monotony of the vacant expanse of water. In addition, I've altered slightly the position of the house to a more frontal attitude so as to create a larger light shape. To give more emphasis to the dark tree area, the flag pole was eliminated. With a stronger, simpler background the white of the house stands out more clearly.

In the sketch, you are able to emphasize and exaggerate certain areas: for instance, more abrupt slope of the land, movement in the sky, more definite white shapes in the light tower and the buildings, the flatness of the sea and as many value differences as you need to give your painting the legibility and interest you feel it needs. The photo only indicates what is there. Seldom is such limited information sufficient for a good painting.

the value sketch

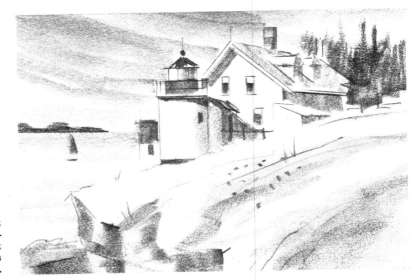

The value sketch is your friend. It will help you make final determinations that are otherwise most difficult when working on the wet paper. It is your plan of attack.

The camera, in effect, provides you with specific details you may need, but it should not restrict you in doing whatever is required to improve the work. Of course, some drawing ability is essential if you hope to effectively translate what you see, as well as what can't be seen.

Observing rock formations, architectural forms, what happens in the sky and trees, etc., can help you to paint the subject while being somewhere else; in your studio for instance. Learning to *see*, not just *look*, is the key to creating good pictures. A retentive memory and a knowledgeable eye are among a painters most valuable assets.

After working on value sketches over time, you'll learn what to look for, what to leave in and what to leave out. Knowledge and understanding of the subject come through observation and experience. Don't despair. Observation can be learned, and experience comes by doing.

The sky is yellow! Where is it written that skies must be blue? This is part of the exhilaration of watercolor—to follow your instincts and enjoy! From a more serious viewpoint, making the sky yellow can help you decide on a compatible color scheme. Color repetition tends to give more unity to the work. And the purples and greens (in the shadows) work well together, providing a color contrast to all the warm elements.

The form in the light tower can be best illustrated by following what retouchers have been doing for years; place the darkest area *not* on the edge, but a bit away from the edge. This emphasizes the "bounce" light and exaggerates the roundness of the cylindrical form.

The rocks provide a good, solid, dark base for the composition. Their form was achieved by using the scraper we discussed earlier.

Spatter was added in the rocks and the ground area. Yellow in the fields suggest brown-eyed Susans that are prolific at that season.

Bright reds in the roofs added a dash of needed color; the suggested shingles were done with a few simple strokes of the ¼ inch flat brush.

the completed painting

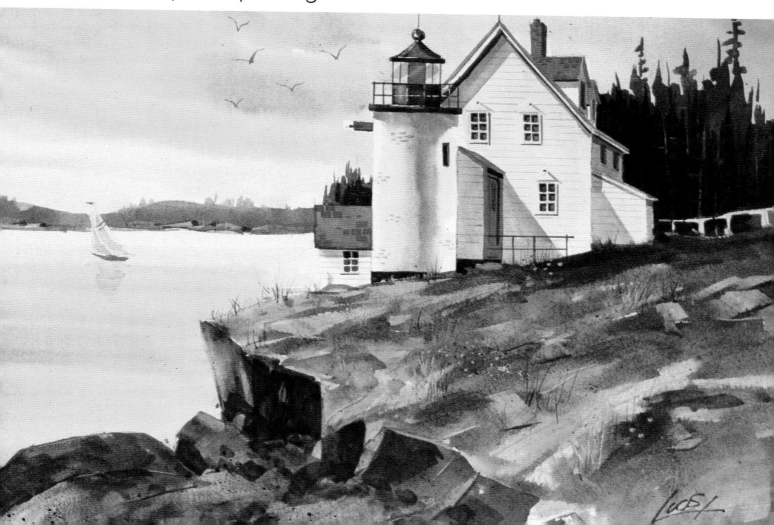

calligraphic

the subject analysis

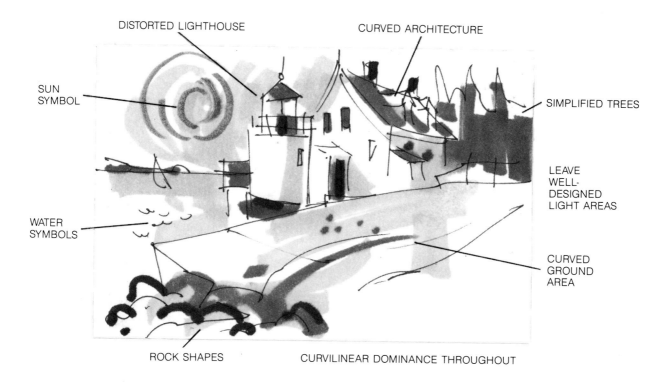

SUN SYMBOL

DISTORTED LIGHTHOUSE

CURVED ARCHITECTURE

SIMPLIFIED TREES

LEAVE WELL-DESIGNED LIGHT AREAS

WATER SYMBOLS

CURVED GROUND AREA

ROCK SHAPES

CURVILINEAR DOMINANCE THROUGHOUT

watercolor at its exciting best!

The photo offers an excellent opportunity to simplify and symbolize the architectural forms and rock formations. Accenting the curve of the rooflines, the one-stroke treatment of the rocks and the oblique ground area handled in sweeping strokes, help create the spontaniety and freshness that are characteristic of the calligraphic style. The sun is symbolized by a series of concentric, colorful curves.

The lighthouse is deliberately distorted in shape, but is still recognizable. The building,

as part of the overall light shape, is treated in the same casual, but disciplined, manner as the tower. The addition of the sailboat provides touches of color and interest in the large sea area. The rocks are described in a series of rhythmic curves. The whole painting has an overall curvilinear dominance that unifies the work. The dark trees serve as needed contrast to the light form of the structures. The cast shadows are used to help describe the forms and further accent the curvilinear dominance.

As you use the value sketch time after time, you will find it becomes easier to create the composition and make decisions as to placement of lines, shapes and values. From the start, you'll find that *where* something is, is far more important than *what* it is. The value sketch shown here is a good example: Note the location of the lighthouse, the placement of the symbolic sun, and the sailboat. Locating the lighthouse on a higher plane

the value sketch

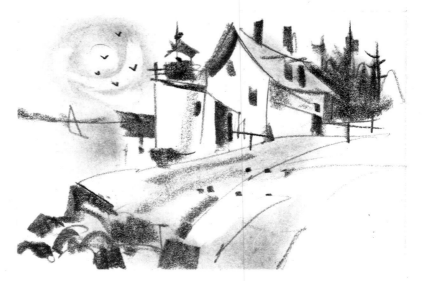

The value sketch is one of your most valuable tools. It's a time saver, because with it you can solve problems at an early stage, rather than trying to do so during the final painting process.

gives it more importance. The sun is positioned left-of-center in the sky area, and the sailboat occupies a spot left-of-center between the lighthouse and the margin. By determining their placement and value pattern in the sketch, makes the actual painting effort itself less difficult. Notice how the oblique line of the land area and the treatment of the rock shapes is made more dramatic in the sketch than it appears in the photo. All of these considerations make for a more positive approach to the painting problem. With careful preliminary planning your brush work in the final rendering will be more spontaneous and there is sure to be a more transparent look to the pigments.

Here is an example of the clarity of a rendering done in a calligraphic manner. No hesitation in the brush strokes, in the color locations, or in the symbolism is apparent. As to procedure, the background colors were washed into soaked paper, then allowed to dry. Then the sky and sea colors were introduced, followed by the darks in the rocks and trees. The final detailing was then executed, finally tying it all into one unit. The same degree of finish is important. That is, consistent handling and brushwork is used throughout the painting.

the completed painting

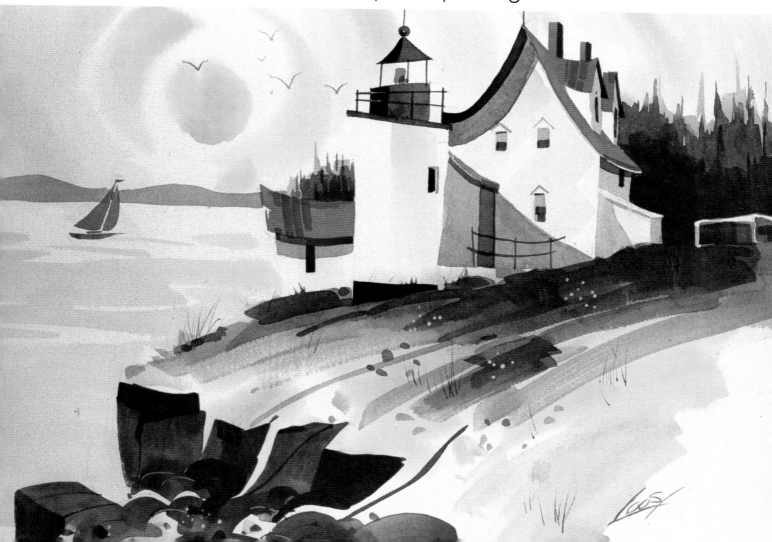

graphic

the subject analysis

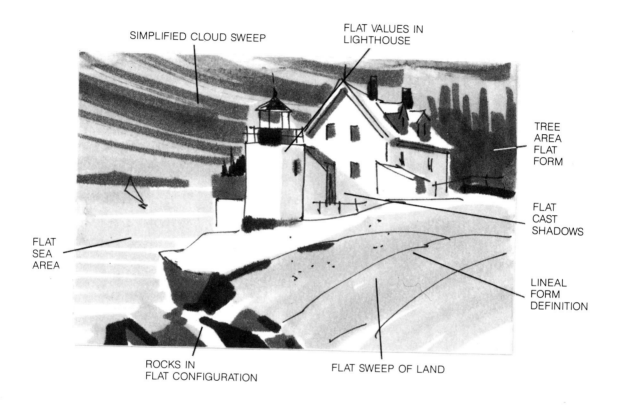

SIMPLIFIED CLOUD SWEEP

FLAT VALUES IN LIGHTHOUSE

TREE AREA FLAT FORM

FLAT CAST SHADOWS

FLAT SEA AREA

LINEAL FORM DEFINITION

ROCKS IN FLAT CONFIGURATION

FLAT SWEEP OF LAND

a good intermix of values and colors . . .

After close examination, a number of changes are suggested to convert the two-dimensional photo, with its value gradations, into a pattern of flat shapes, values and colors with no gradation whatsoever. As we have already decided from our earlier analysis, the lighthouse is too low in the composition, the land is too flat, and the rock area is indefinite or not shown at all. The sky has to be made more interesting, and the light shapes should create a better pattern.

The forms used in the graphic style can contain *no* gradation (change by imperceptible degrees) in value or color. Therefore, it is neccessary to describe form by using a progression of perceptible color or value planes. This is shown clearly in the dramatic sweep of the land area.

For a more impressive light shape, the trees must be darker to support and enhance the lighthouse and building. Subdivide the rock area into a series of more varied forms of contrasting values. The windows, fence, sailboat, foreground vegetation, and birds, are added to complete the picture.

Using the information gained from the analysis, a sketch should be made that incorporates these changes. Place emphasis on the treatment of the light and dark areas, the oblique areas of land, and the sweep and movement of the sky and the sea. The discipline throughout the whole piece is to think constantly—"flat"—and to avoid the urge to include value and color gradation in the sketch.

The value sketch helps set the tone and

the value sketch

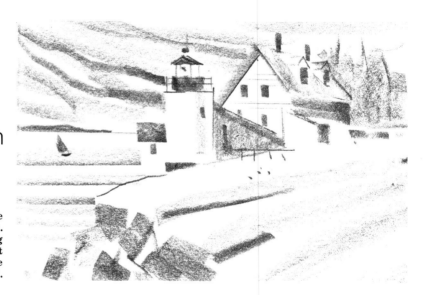

The value sketch helps set the tone and rhythms in the finished work. Close attention to it when painting will help in deciding where abrupt changes in the values and color are needed.

rhythms in the finished painting. I can anticipate future problems in the design and adjust the sketch accordingly. I can alter shapes and sizes, and, for better relationships, change the values to read more clearly.

My approach to the rock area was to create the illusion of big shapes broken by smaller pieces. It's important to avoid monotony in this area. Take care to vary the sizes, values and colors, and use the darks to create a sense of rhythm, pattern and stability. How you establish your darks is the most important means you have in making the white areas effective. The only way the salient sections of the light values of the lighhouse will stand out and become the focal center is to contrast these areas with strong darks. This requires planning and making adjustments that are not apparent in the photograph. After all the placement and value decisions are made you'll be ready to start on the final rendering at last.

The initial step calls for introducing the midtones to establish the values that create the light forms. Think of the top surfaces of the various forms as being the lightest values, and build around them. A few darks are added to help key the other values. The strong obliques are anchored by the strong horizon line.

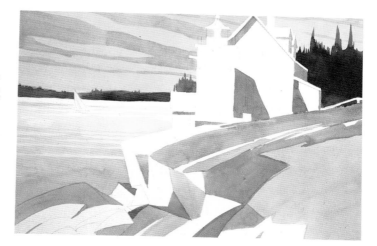

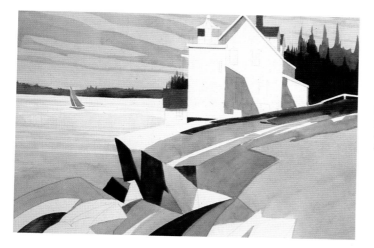

More value changes are added for better definition in the rocks and trees; cast shadows from the buildings are introduced along with darkened values in the ground.

I now tie the flat forms together with line and additional darks. Intricate work on the dome, birds, and windows are added. The rigger brush is used for the fence at the base of the house, flowers and grass.

In the final painting you can see how all areas have been described as simple flat forms. The design is strong because of the clearly stated pattern of light and dark. By holding detail to a minimum you enhance the large flat areas. The sweep of sky offers some needed conflict and movement as a counter-point to the desired static flatness of the subject matter. A graphic style can have much visual appeal.

the completed painting

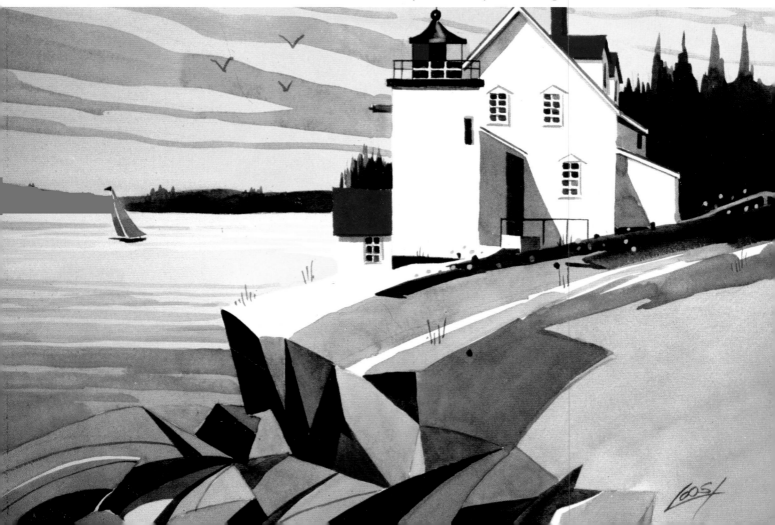

abstract

the subject analysis

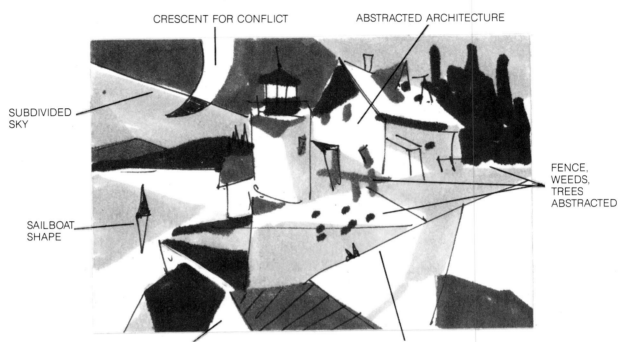

CRESCENT FOR CONFLICT

ABSTRACTED ARCHITECTURE

SUBDIVIDED
SKY

FENCE,
WEEDS,
TREES
ABSTRACTED

SAILBOAT
SHAPE

ABSTRACTED ROCKS

GROUND AREA IN ABSTRACTED FORMS

obliques—a good place to start . . .

In analyzing the subject with an eye toward abstracting it, look for lines or seams from which you can project new shapes, forms or lineal movement. These seams can also be used as changing points for directions, values or colors. For instance, the vertical that forms the left side of the lighthouse, the straight line of the horizon, the strong oblique areas in the sky, and the cast shadow on the structures, are all take-off points that you can transpose into a great variety of forms and shapes. All it takes is imagination and courage in the way you exaggerate and distort reality to express more than is apparent in the photograph.

Once you have determined basic forms and shapes, then study the subdivisions of these shapes. Try to avoid areas and shapes that are too similar in size. While doing this, try to maintain an image of the essential forms of the lighthouse. It has certain characteristics such as the dome, the dormers on the house itself, the strong vertical shape of the subject—the key areas to consider in the "abstracting" process. Along with all the straight and angled areas look for some curved relief that will serve to enhance the design. The most promising location for this is the long line in the sky. Is it not apparent how the subdued cloud indications in the photograph eventually evolved into the crescent shape indicated in the upper left corner of the sketch? This is the result of the kind of thinking and rearranging that goes into creating an abstraction.

From the subject analysis, it is simple to proceed with the value sketch. As in the case of the graphic style, try to think in terms of flat shapes, but with a different result in mind. Here the goal is to break up the flat areas into abstract forms, without completely losing the identity of the lighthouse.

It is easier in the value sketch to indicate more subtle flat value variations than in the subject interpretation which I did with mark-

the value sketch

Make several value sketches since they are quick and economical. A sketchbook can be used as a reference many times over, and the images they project can prod you into painting time and time again.

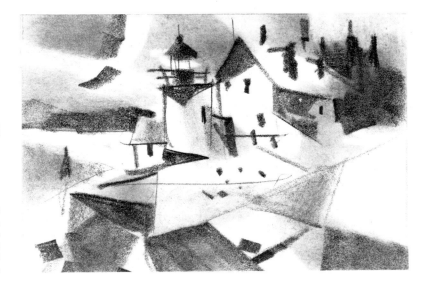

ing pens—two grays and a black. These variations throughout the sketch in the sky, rocks, foreground, buildings, lighthouse, sea and tree areas. With the pointed edge of the pencil I can indicate more clearly the minor details such as windows, chimneys, rock striations, and the lighthouse.

From this point on, with the major decisions made, I am more confident about beginning the final painting phase.

Study this finished painting: Does it say "lighthouse" in a series of abstracted shapes? Are the basic principles of design observed? Does it read in its mix of value and color? I think it does.

Observe how the values and shapes repeat and echo each other, giving the painting its overall unity. Even the fractured shapes and color deviations, the essence of the lighthouse and its surroundings are maintained. Notice, too, the white shapes and their relationship to the values and colors that surround them. Their shapes and sizes were carefully thought out in the preliminary sketches.

I've tried to keep the number of small areas to a minimum so the emphasis stays on the larger shapes.

Knowledge of the subject and its characteristics makes it easier to abstract the basic form and yet retain its identity.

the completed painting

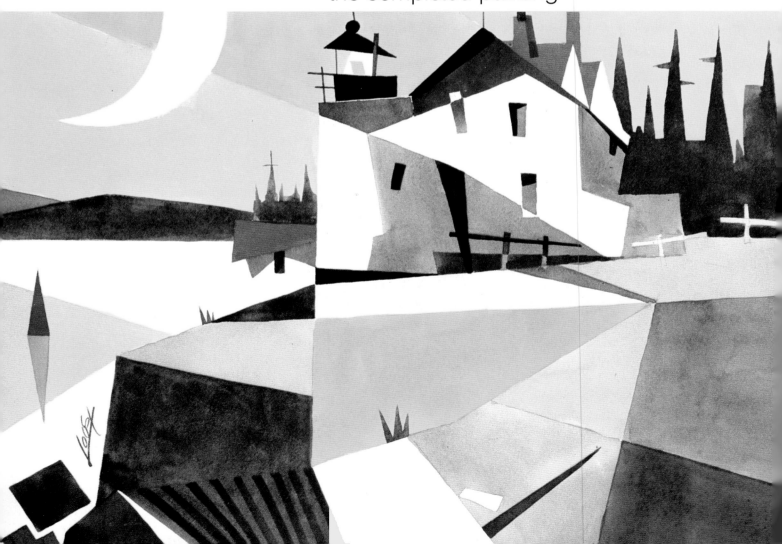

on gesso

the subject analysis

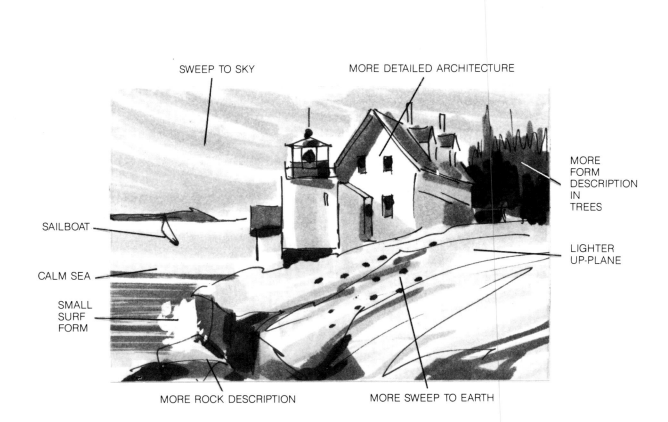

SWEEP TO SKY

MORE DETAILED ARCHITECTURE

MORE FORM DESCRIPTION IN TREES

SAILBOAT

CALM SEA

SMALL SURF FORM

LIGHTER UP-PLANE

MORE ROCK DESCRIPTION

MORE SWEEP TO EARTH

for a more textured look . . .

Analyzing the photo for use in the gesso approach again follows the traditional way. Composition is always a paramount concern since good paintings depend on good composition. It is essential to evolve a sound plan at the outset. If I fail to start a painting without sufficient preliminary planning, a disaster usually occurs.

As in the traditional approach, it seems wise to move the lighthouse to a higher elevation to accent its importance by looking up at it. A more dramatic sweep to the ground level and larger foreground rocks will help. Flatten the sea to create a quiet area between the sky movement and the jagged rocks. Also, it seems a good plan to shift the position of the lighthouse to a more profiled view and make the roofline more angular. Minor details can be added later.

In a subject as full of clutter as the boatyard, don't try to draw everything you see. There just isn't room. Simplify. Leave out non-essentials. Notes on the details you might need can be made along the borders, with small drawings as reference. The overall pattern can be developed by indicating the larger forms in the darks and midtones. You can easily indicate a dark line of pine trees by using the flat edge of a chisel-point sketching

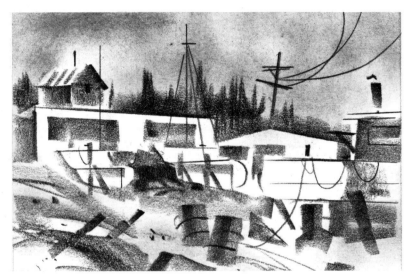

the value sketch

When decisions regarding space divisions must be made, the value sketch is the place to make them. It saves time and prevents many disappointments in the final rendering.

pencil in a vertical zig-zag movement. Value changes in these trees can be achieved by varying the pressure on the pencil. Rub a small piece of cotton which has been saturated with graphite from the sketching pencil, into the larger areas of the sketch to indicate subtle values. A kneaded eraser is ideal if you want to lighten parts of these values.

The edge of the chisel-point pencil is also an excellent tool for the indication of the calligraphy, as in the telephone pole, ladders, masts, and the small bits and pieces in the ground areas. The sagging ropes and telephone lines can be sketched in with an ordinary pointed pencil.

the subject analysis

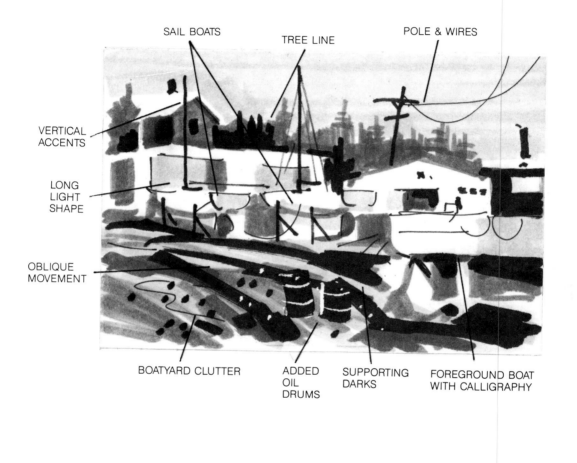

SAIL BOATS

TREE LINE

POLE & WIRES

VERTICAL
ACCENTS

LONG
LIGHT
SHAPE

OBLIQUE
MOVEMENT

BOATYARD CLUTTER

ADDED
OIL
DRUMS

SUPPORTING
DARKS

FOREGROUND BOAT
WITH CALLIGRAPHY

there is unity in the "wet-in-wet"

In the boatyard sequences, I was faced with much more detail than I had with the barn and the lighthouse. As I analyzed the subject, I became aware of the possible traps involved. The main problem was to be literal and still maintain a good design. The plan I decided on was to keep the boats and other major forms more or less in place, but recompose the background and then tie everything together with calligraphic marks.

Starting with the sky, I repeated the value in the ground area of the boatyard. The darks were then introduced which created a

well-shaped light area from upper left to lower right. The boats were carefully drawn and positioned and given identifiable values. The house, upper left, and the long low building, center left, were played down in value to hold the emphasis on the foreground yard area.

The rusty oil drums in the foreground were added—they do not appear in the photograph, but rusty oil drums are likely to be found in most boatyards. Their addition allows for nice color touches later on in the rendering. Now it was time for the more detailed value sketch.

traditional

subject III

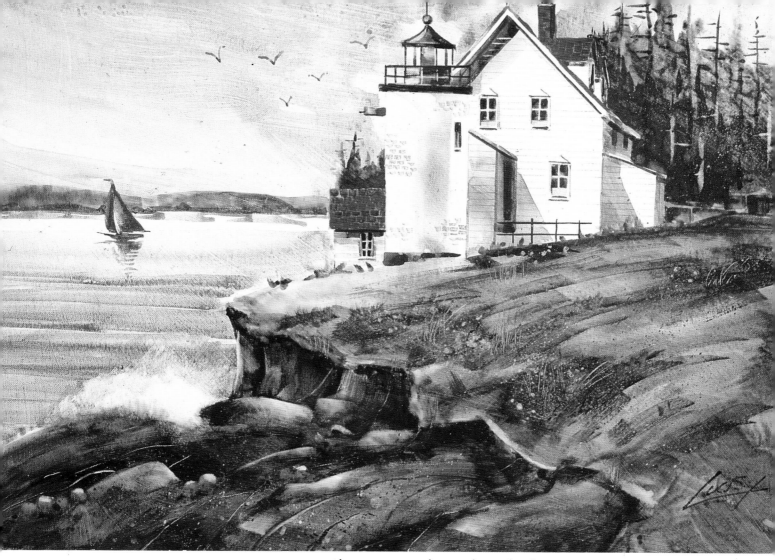

the completed painting

In its final form, the gesso rendition closely resembles the traditional style, but with a few major differences. Notice the difference in the texture: Thick pigment, seldom used in transparent painting, has been applied. This was done to overcome the resistance of the gesso-covered paper. The result is a resemblance to oil or acrylic renderings.

In addition, notice the extra touches in the brickwork of the lighthouse and the lift-out of the trees in the background, and the form in the rocks. The lift-out of the pigment in the trees and rocks was done with a damp brush, then the areas were repainted. Another method of lifting the pigment can be achieved by spraying the area with a water-filled atomizer (plant-mister, pump-style bottle etc.) then dabbing it with a tissue or cosmetic sponge. The flower and grass areas were handled in this manner. Loosening the pigment can also lead to the use of the knife and scraper strokes.

This gesso sketch follows rather closely the approach used when working in the traditional manner, but with an eye toward a more detailed result. As in the analysis, move the lighthouse to a higher position in the sketch, introduce more value gradation in the ground area, and increase the size of the rocks. Remember, it is fairly easy to add texture to the final rendering when using gesso covered paper, since the paper surface

the value sketch

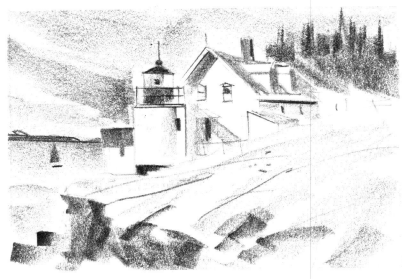

Think of the value sketch in terms of building a home. You certainly would not start construction of a house without blueprints. Consider this your blueprint for building a well-designed painting.

is more textured than standard watercolor sheets.

In its basic plan, the sketch is a helpful factor in building a successful picture. However, when working from your sketch keep in mind it is not necessary to become a slave to it. Be flexible, and make changes and alterations you feel necessary along the way.

In the final sequence I painted the sky into wet paper. The paper was tilted to create a small sag to the clouds which produced the effect of a cloudy day. This same color was also introduced into the ground area to repeat the sky. A dark, rich green was used in the tree line and was also repeated in the foreground. To create the illusion of distance, the foreground color was intensified. Even though it was a cloudy day, I arbitrarily introduced a light source from the right to show more value change in the boats and buildings. Before starting to paint I had carefully sketched in the boats, structures and other details. I now began to paint these areas. The large forms were painted first and the darks were indicated in such places as the doorways, windows, the cabin of the boat on the right, and the buildings at upper left. The calligraphy was the last; the figure, ropes, ladders, scattered lumber, the lettering on the boats and building, and the spatter in the foreground. The result: a typical Maine boatyard in its varied and interesting disarray.

the completed painting

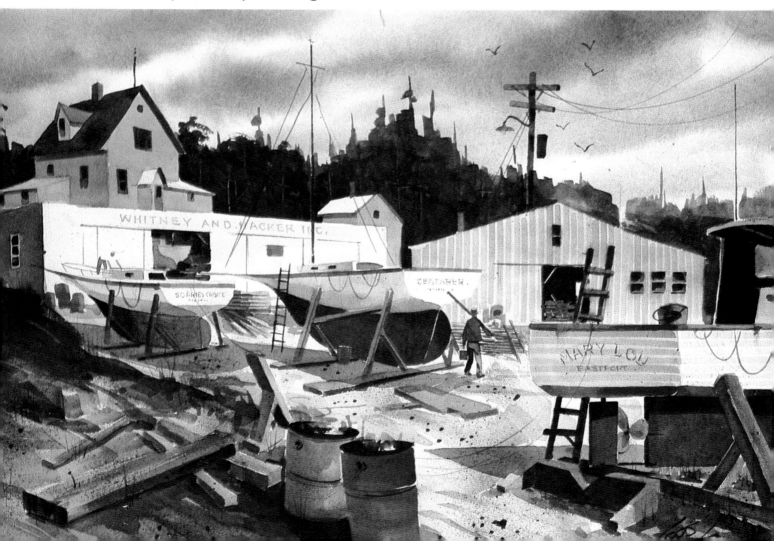

calligraphic

the subject analysis

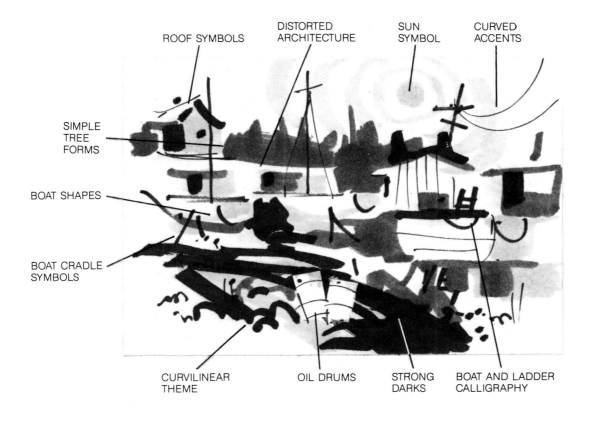

ROOF SYMBOLS

DISTORTED ARCHITECTURE

SUN SYMBOL

CURVED ACCENTS

SIMPLE TREE FORMS

BOAT SHAPES

BOAT CRADLE SYMBOLS

CURVILINEAR THEME

OIL DRUMS

STRONG DARKS

BOAT AND LADDER CALLIGRAPHY

true transparency . . .

The photo shows unlimited possibilities for the use of symbolism and simplified forms which are the essentials for painting the calligraphic style. The architecture, the sailboats, the lobster boat, the masts and poles, the accumulation of material that is indigenous to a boatyard—all are naturals in symbolic terms. Sweeping curves tend to dominate with the sun, the boat hulls, the sagging lines and wires, and the ground movement and all of these elements translate nicely into a free-swinging, spontaneous-looking calligraphic painting. There are sufficient straight lines—the poles, boat cradles, and mast—to offer conflict and create contrast to the curvilinear dominance.

The key to this type of painting lies in taking from the photo just what you require, as in the relationships of negative shapes to the positive in size, value and direction. These determinations are made as the value sketch is developed. In the interest of good design, *where* you position the elements in the sketch is more important than *what* they are.

As we have already noted, the use of the value sketch improves your chances for producing a more successful painting, and makes the sequential painting steps themselves easier.

When preparing the value sketch for the calligraphic type rendering, imagine your sketching pencil to be a brush, and move it in sweeping and direct strokes. Such an approach will create a more positive attitude

the value sketch

The use of the value sketch improves the odds for a more successful painting, and makes the sequential steps easier. It eliminates a lot of the guesswork and you won't waste time in the painting process hoping for lucky accidents to happen.

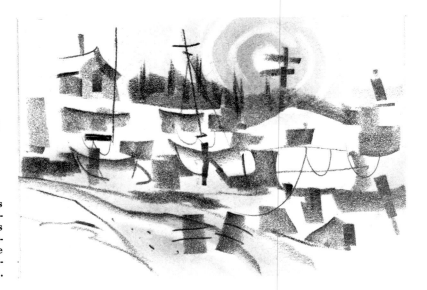

that will carry over into the painting phase.

Indicate the strokes of the rooflines, the identifying sweep of the boat hulls, and the building itself. Consider the locations of the intense dark areas and their relationship to the adjacent areas. Don't make them static forms. Add interest, not only in the overall shape, but *within* the shape. Try connecting some of the horizontals with interesting perpendiculars. A boatyard offers such a multitude of diverse and unusual areas that it becomes necessary to be selective in deciding what to include and what to leave out.

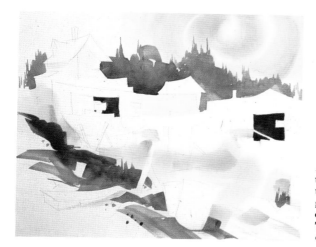

After sketching in the simple forms, I painted in the curving yellow sky, with repeated accents in the foreground. The dark trees in the background and the left foreground were added as oblique areas to counter the horizontal tree line. The darks of the doorways help to key the rest of the colors.

Warm reds were used to indicate the buildings, the boat hulls, and the rusty oil cans. More intense dark green was added to the tree line to delineate the houses and buildings. Treated as calligraphy were the telephone pole, the boat's cabin and hull, and the cast shadows from the roof edges.

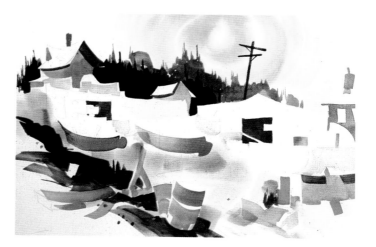

More calligraphic details were introduced—windows, boat cradles and signs. A cool cast shadow was added to the roofline of the building, right center, with the building, left center, improved by a cast shadow on the left.

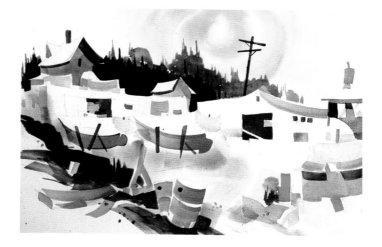

Ah! Here is the joy and excitement of watercolor: the rhythm and beauty of the transparent washes—the freshness of the single stroke—the deliberate omitting of defining lines, allowing the negative and positive areas to work in harmony with each other.

Note the repeated areas of colors and their varying size relationships. The curves are strong but there is sufficient horizontal and vertical emphasis to offer variety and create interest as well as stability.

I consider the calligraphic approach an exercise in "planned carelessness." At the same time it is perhaps the most disciplined method of painting with watercolor that I know. There is more thinking involved with each brushstroke, because each one has to be just right. If you go too far and overwork an area, the richness and transparency of the color will be lost. It is not an easy procedure, but the happy result more than compensates for all the thinking and planning necessary throughout the rendering.

the completed painting

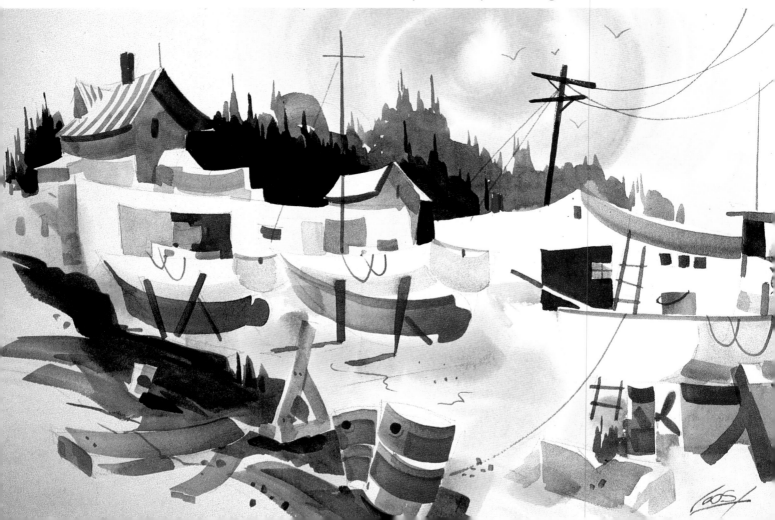

graphic

the subject analysis

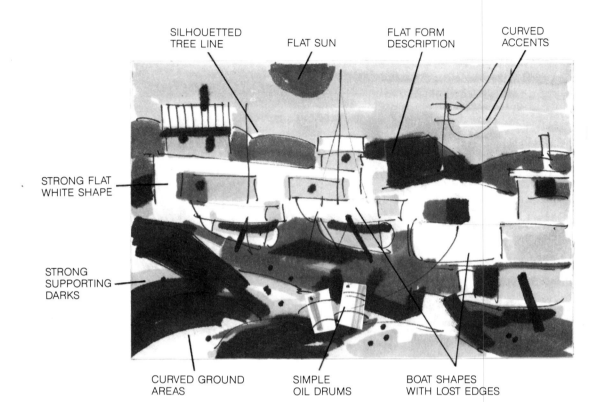

SILHOUETTED TREE LINE

FLAT SUN

FLAT FORM DESCRIPTION

CURVED ACCENTS

STRONG FLAT WHITE SHAPE

STRONG SUPPORTING DARKS

CURVED GROUND AREAS

SIMPLE OIL DRUMS

BOAT SHAPES WITH LOST EDGES

shapes in a positive, strong pattern . . .

The boatyard rendered in graphic style presents an abrupt change from the calligraphic method. Whereas the calligraphic handling stressed a curvilinear dominance with straight accents, the graphic emphasizes straight shapes and lines with curved accents. So, in the analysis, we look for elements that can be represented by simple, flat planes. Architectural planes are fairly easy. But other forms, such as the ground area require more thought. Such areas have to be broken by values and curved or straight directional lines to suggest their horizontal planes.

Since there are no open doors in the boatsheds in the photograph, we'll create some in order to add darks for more interest. Perspective is suggested by the directional lines in the large white shape of the building, the ground, and the timbers.

Eliminating a few descriptive edges, as in the boats and buildings, will aid in creating a large, strong, uninterrupted light shape. These larger shapes are enhanced by the small bits of calligraphy—the oil drums, cradles, ropes, etc. Some shape repetition is evident in the boats, the inverted V's of the roofs and tree line, the curves of the wires and ropes, and in the ground forms. Rectangular repetition is found in the roof, upper left, the doors and windows, oil drums, and the boat's rudder. Look for such areas in your photo, and if they're not there, be creative and invent them.

Start the value sketch by covering the entire rectangle with a midltone of gray using the graphite-coated cotton. Now, take your kneaded eraser and pick out the hard light areas. This will establish the light shape flow from upper left to lower right. Next, using more pressure on the pencil, indicate the dark areas. This sequence will build the strong design pattern. Add darker midtones, as in the boat forms and ground areas. With the pen-

the value sketch

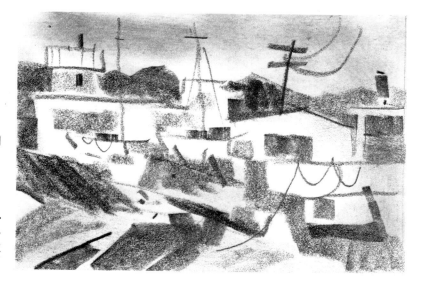

The flat sketching pencil is ideal for indicating the graphic style. Strong, flat, value areas, and curved strokes, can quickly form a strong basic pattern.

cil's edge add some of the calligraphic and descriptive line work, as in the ropes, wires, masts and ground area.

Study the sketch from a short distance. Look at the overall relationships. Do they relate as to size and value? Are they connected so as not to float? Do the lines define and help the large areas? Do the lineal directions suggest perspective? If you answer "yes" to these questions, you are ready to start painting.

Laying in the sky was my first move—keeping it flat and in a midtone value. I painted this area to the tops of the buildings because I knew I could cover it with the dark green tree silhouette in the background. The warm earth color in the ground area was applied next. A warmer, stronger earth tone was used on the house, upper left. A darker value indicated the cast shadows of the boats. A richer green was used to provide form description lower left and right. I used a warm sienna in the center sailboat, the oil drums, the rudder, muffler and propeller of the lobster boat lower right. The darks were next, used in the doorways, the cabin's shadow, and the curved stroke, lower left center.

Calligraphy was the final touch—the wires, ropes. cradles, small oil drums in the background, and the small windows.

the completed painting

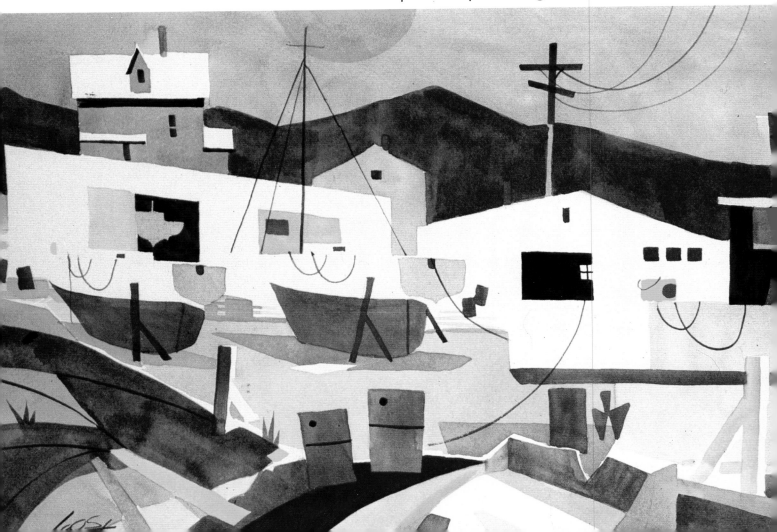

abstract

the subject analysis

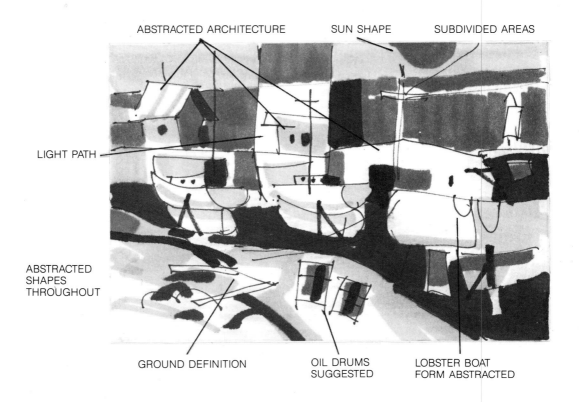

ABSTRACTED ARCHITECTURE SUN SHAPE SUBDIVIDED AREAS

LIGHT PATH

ABSTRACTED
SHAPES
THROUGHOUT

GROUND DEFINITION OIL DRUMS
SUGGESTED LOBSTER BOAT
FORM ABSTRACTED

basic drawing is a must!

Under close analysis, the photo suggests several lines of division that can be used as places to begin abstracting. The small sketch at the left illustrates these basic lineal divisions and directions upon which these abstracted forms can be constructed. Working from the established lines, the shapes of the house, upper left, the centered building and the boat shapes become integral parts, and serve as various starting points. After the forms have been abstracted from the traditional shapes, some decisions have to be made as to value, size and direction. Should some forms be positive or negative? Where should these change-overs occur? The answer must come from your own sense of design. Each move seems to dictate the next one. All forms are "fractured," but with the aim of maintaining the integrity of the subject. The end result should suggest "boatyard" without too many literal clues for the viewer. Maintaining tight discipline and control of your design should help.

The straight lines are dominant, with curvilinear accents in the form of the sun shape, the ground curves, and the hanging ropes.

From the observations that have been made from the subject analysis, start with the light shape by accenting it with the midtone values. Think flat and abstracted forms. The sharp value changes and shape delineation combined with positive and negative forms are part of the basic concept of abstraction. Avoid using literal forms, but try to retain the shapes, values and color that suggest that the scene is a boatyard. The viewer

the value sketch

Establish a rhythm in the placement of the forms and make them entertain in their journey. Accent the light areas with the dark and midtone values and make them read as distinct parts.

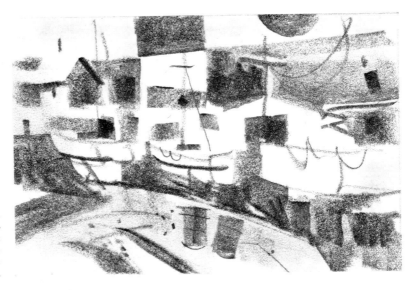

should relate to what you have in mind.

When the elements are well established, and form a pleasing design, we can tie them all together with calligraphy and with lineal description. Now we are ready to get on with the final painting.

The small sketch at the left illustrates these basic lineal divisions and directions upon which the abstracted forms can be constructed.

By following the basic steps in the value sketch, I find I am able to approach the painting itself with more ease and confidence. The first phase is to subdivide the sky with sharp angles and obliques, and then repeat these angles in the foreground.

Some of the distorted shapes are varied to avoid monotony and to provide counterpoint to the other abstracted forms. Too many of the same-size areas make up a composition that is static and monotonous to the viewer.

The major decisions then were: what colors to use, and what their relationship are to each other. The background was rendered in warm greens and greys with accents of burnt sienna, cadmium orange and red. The warm dominance was countered by isolated cool blues and lavenders in the boat hulls, buildings and foreground. I rarely use black, but in this case it seemed appropriate. Here the black gives strong support to the upper part of the painting and helps the design.

Some linear additions that suggest masts, poles and ropes are used as final touches, tying the whole design together to form a unified painting. These final details also supply a few clues so the viewer can more easily identify the abstracted scene.

the completed painting

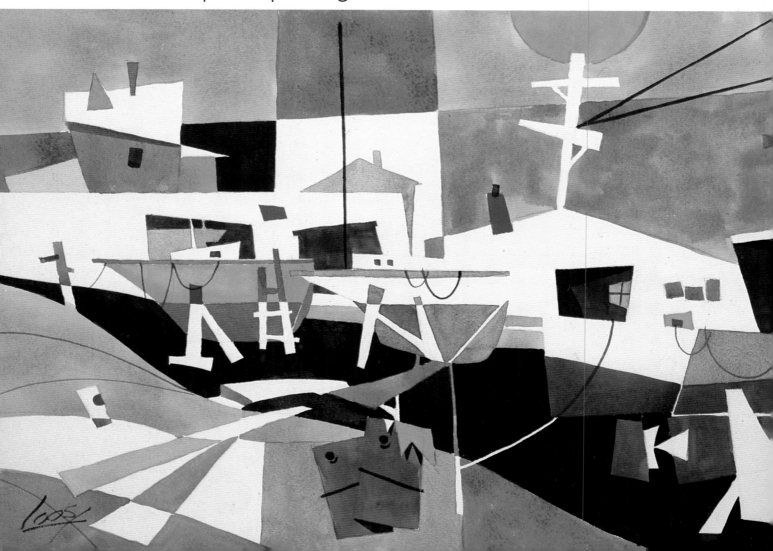

on gesso

the subject analysis

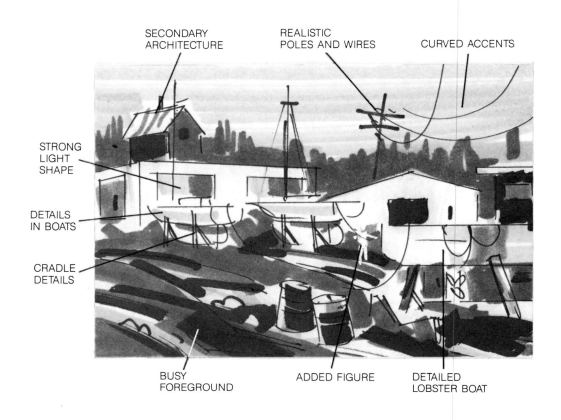

SECONDARY
ARCHITECTURE

REALISTIC
POLES AND WIRES

CURVED ACCENTS

STRONG
LIGHT
SHAPE

DETAILS
IN BOATS

CRADLE
DETAILS

BUSY
FOREGROUND

ADDED FIGURE

DETAILED
LOBSTER BOAT

a flexible and mobile technique . . .

Painting on gesso allows me to be as literal as I wish, so the subject analysis takes into account most of the detail. As in the traditional approach I make sure all the details support a sound design plan. I feel that drawing can be superimposed over a valid design, but it is very difficult to superimpose a good design over a drawing already weak in design. It is well to consider the design concept as the basis for the entire painting, otherwise there is very little to hold the drawing together as a unified piece.

Note that no painting was done in the sky,

leaving only the gessoed paper. This is deliberate. I have found that the gesso-covered paper has a bluish cast (being a cold white) when placed in a neutralizing mat, so I can get a suggested blue sky without having to paint it.

When your design is established, examine the photo for all the detail possibilities. Others may be added, whether they actually appear in the photo or not. If you need more details, here is a chance to demonstrate your creativity.

On the detailed rendering in gesso style, I follow the same sequence I use for the sketch. First, I establish the midtone, pick out the light areas, and put in the darks. This establishes the basic pattern on which to build the painting. From this point I can concentrate on the calligraphic details. These are introduced with a sharp, pointed pencil, delineating the wires, ropes, ladders, timbers, windows, poles and masts. Location of these

the value sketch

I wield my pencil as a brush and use the information from the photo to my best advantage, realizing that this is the blueprint for the actual painting.

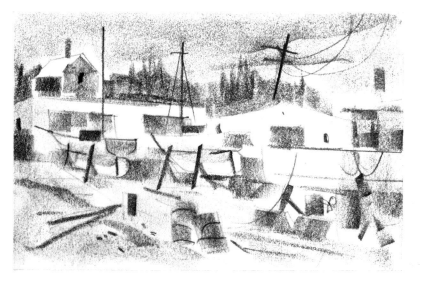

items is important, so I place them with care.

I think this stage could be called "the valuable sketch," since it gives me "valuable" information and confidence needed to confront the blank sheet of white paper used for the final rendering. With a satisfactory value sketch in hand, my concerns can be directed toward the more esthetic problems such as: *what colors?* and *where?*

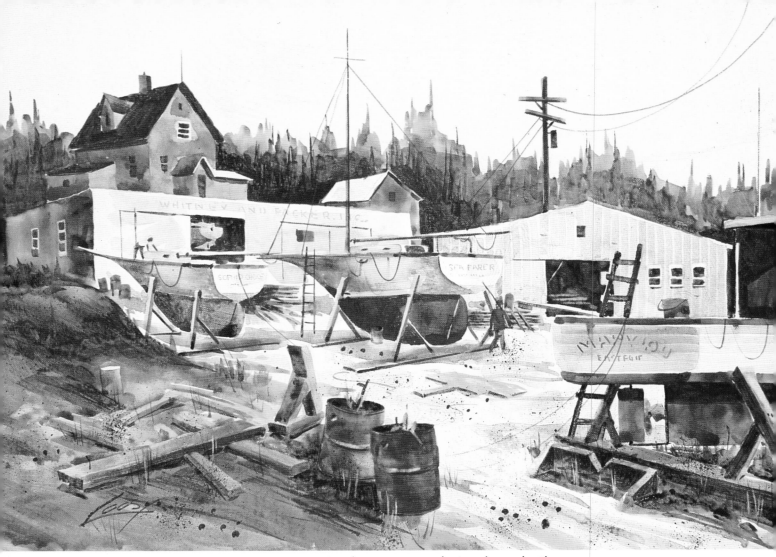

the completed painting

The image I have in mind for the finished work closely resembles a traditional painting, but with a few major differences. Note the absence of color or value in the sky as discussed in the subject analysis. With all the activity going on below, a calm, unadorned sky serves best. All other sections of the painting are virtually the same as the traditional example, but with more textural variety, and much more application of pigment. "Lifting" has been used sparingly, but effectively, as in the grasses, the suggestion of detail in the dark doorways, and oil drums.

The painting is basically warm with green, browns with blue, and lavender accents. A bright red touch is used in the middle figure. Spatter is added to describe the untidy foreground commonly found in boatyards.

subject IV

traditional

the subject analysis

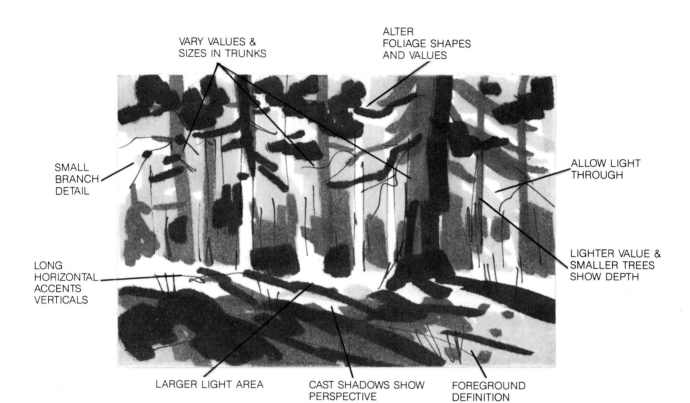

VARY VALUES &
SIZES IN TRUNKS

ALTER
FOLIAGE SHAPES
AND VALUES

SMALL
BRANCH
DETAIL

ALLOW LIGHT
THROUGH

LONG
HORIZONTAL
ACCENTS
VERTICALS

LIGHTER VALUE &
SMALLER TREES
SHOW DEPTH

LARGER LIGHT AREA

CAST SHADOWS SHOW
PERSPECTIVE

FOREGROUND
DEFINITION

accent the softness with hard edges . . .

Verticals and perpendiculars are everywhere in this photograph. The upright thrust of the trees is countered by the horizontal ground area and accented by the flickering light on the ground and in the foliage. There are many trees of the same girth and angle, but for design's sake and interest, these are altered to avoid monotony and a static appearance. It is also important to create a variance in the gaps between trees—the negative shapes—since they, too, can become boring if the placement is too even.

Large masses of dark values are used to suggest the foliage and form is achieved by varying the values in these masses. Notice how the smaller branches are used to tie the larger foliage areas together. Lighter and grayer values are used in distant trees and ground areas to suggest perspective and depth.

The foreground requires more detailed work, and this is accomplished with smaller pieces of dry brush ground vegetation and spots of brighter color. Also the cast shadows of the trees are varied as to size and value.

The trees in the photo as already noted are similar in size, and therefore, are static and uninteresting. Therefore, I deliberately made the tree on the right larger and more heroic in appearance. This change established the painting's center of interest, and create better relationships in the sizes of all the trees.

The photo has excellent light and dark patterns, as in the light form in the left fore-

the value sketch

Since the value sketch is my plan from which a better painting can evolve, I put ample time and thought into it.

ground. Its movement and direction offer a good counter to all the perpendiculars. The light shape provides a solid base for the whole design. More detail in the foreground gives the illusion of depth making the tree area clearly identifiable.

The value sketch is useful in the indication of more subtle value changes. The pencil can delineate the hard line areas, and with the smudge of a finger, I can soften a passage, or tie one area to another, as in the leaf forms and foreground. I often experiment at this time, making numerous sketches, until I find the one that most pleases me. This certainly is the time to try a variety of approaches because with just a kneaded eraser and graphite, changes and alterations are simple at this stage. A line here, a shape there—and it's amazing the control you can wield. Don't hesitate to make changes: they can often be for the better.

I wanted a warm feeling throughout, so an overall wash of three parts of cadmium yellow light mixed with one part raw sienna was my first step. Not only did it give the painting a warmth, but it provided one of the essential factors a painting must have—unity. The dark tree trunks were then painted with a mixture of cobalt blue and burnt sienna, varying the proportions to either make warm (more burnt sienna) or cool (more cobalt blue) tree trunks to avoid color sameness. The trunks also provided the repetition of negative and positive vertical forms. Dark, warm greens were painted into the foreground that accented the horizontal light area. These strokes were made by a sideways and "pushed" stroke of the large round brush.

The calligraphy was then introduced: the smaller trunks, limbs and twigs, and spatter in the foreground. Accents of burnt sienna and cadmium yellow light were added to provide life to the dark masses of foliage and growth in the foreground.

The end result is a positive statement, a painting that says "woods" with the dominant verticals, the secondary horizontals, and a light and dark pattern that adds interest and creates a feeling of depth.

the completed painting

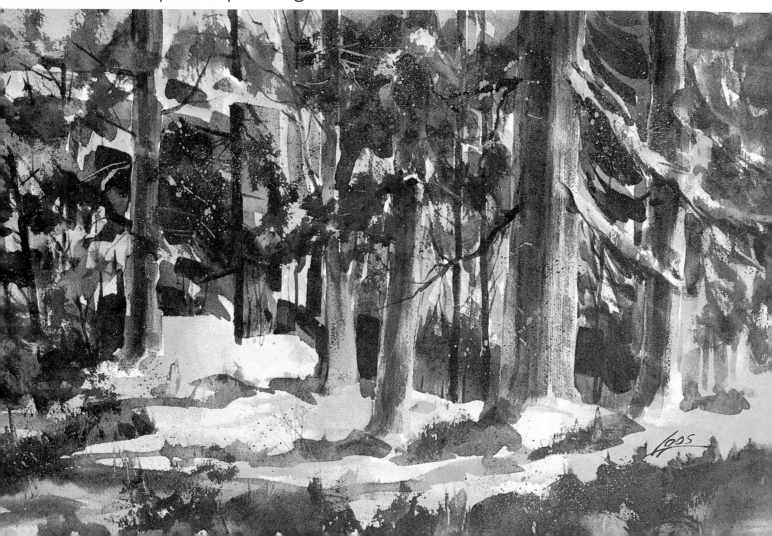

calligraphic

the subject analysis

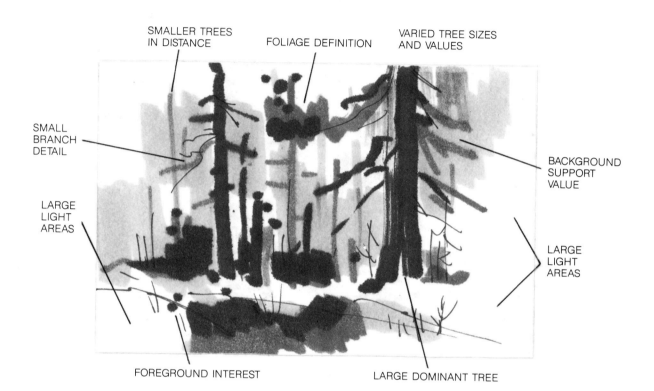

SMALLER TREES IN DISTANCE

FOLIAGE DEFINITION

VARIED TREE SIZES AND VALUES

SMALL BRANCH DETAIL

BACKGROUND SUPPORT VALUE

LARGE LIGHT AREAS

LARGE LIGHT AREAS

FOREGROUND INTEREST

LARGE DOMINANT TREE

a very disciplined approach . . .

It is, indeed, a challenge to convert the forest photo—an intricate mass of trunks, branches, foliage and ground area—into a fresh, disciplined, undetailed painting retaining a *feeling* of spontaneity. I decided to start with a large middle value shape positioned on the paper so as to leave the four corners white, making certain these corners were of different size and shape. Into the large middle value I placed trees of different value and size, conscious of the negative spaces between, which also should be different sizes and values to avoid monotony. Horizontal curvilinear movements in the foreground are used to counter the vertical straight dominance of the large tree trunks. The dark rocks, although not present in the photo, were added to provide more variety and interest in the foreground.

The foliage had to be simplified without losing its identity as a mass of leaves, twigs and branches. Details need only be suggested and to accomplish this the brushwork in the painting will be done with as few strokes as possible.

Distant trees and branches are handled in lighter values to keep them from taking the emphasis from the upward thrust of the foreground trees. Notice that a birch tree was included as a contrast to the darker trunks.

The value sketch is an excellent opportunity to simulate the type of brushwork you will use in the final rendering. The straight strokes of the tree trunks, the sweep of the foliage, and the simplification of the background, can all be done with the broad-tipped pencil. Varying the pressure on the point will indicate value changes.

As in the traditional rendering, the largest tree has been kept on the right to avoid cen-

the value sketch

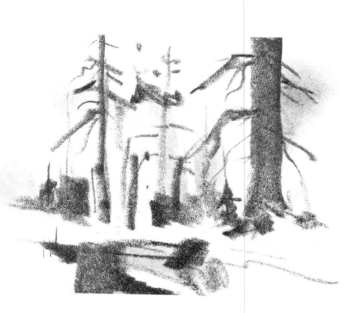

Trees are a natural for rendering with the broad-tipped sketching pencil. Varying trunk sizes can be indicated by changing the angle of the point.

tering the focal area. Small spots and oblique strokes near the trunks simulate foliage and leaves.

An artist's creativity is reflected in his ability to symbolize ordinary objects around him or her. Try to simplify these objects in as few strokes as possible, almost as if you are trying to caricature them. Look for those identifying characteristics in nature that can be distorted and simplified without losing their identity.

The spontaneity and sparkle of the calligraphic approach is exemplified in the completed rendering of the forest. The simplified background with strong brushwork in the tree forms combines with the symbolized foliage and rocks to create a unified and fresh quality to the painting.

Colors are bright, crisp, and transparent, from the varied greens in the foliage, to the yellows and siennas in the foreground. Transparency is important to the freshness of watercolor, and it is easily lost by too many brushstrokes. I can't overemphasize the importance of the discipline necessary to plan and render this type of watercolor. The freest and freshest watercolor painting is the result of careful planning and knowledge of the subject, and maintaining strong self-control throughout.

the completed painting

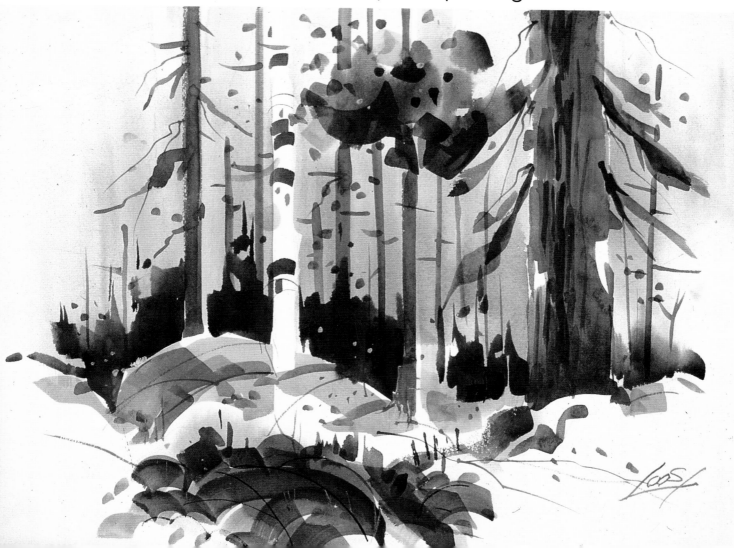

graphic

the subject analysis

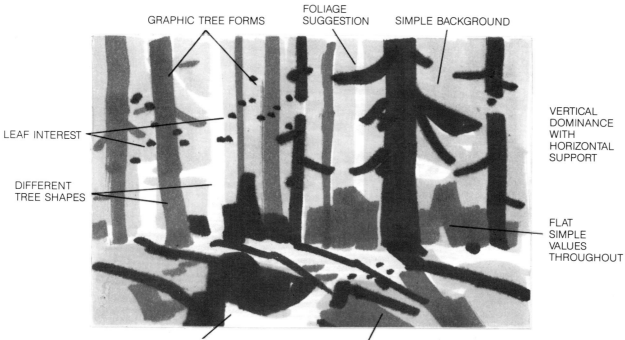

GRAPHIC TREE FORMS

FOLIAGE
SUGGESTION

SIMPLE BACKGROUND

LEAF INTEREST

DIFFERENT
TREE SHAPES

VERTICAL
DOMINANCE
WITH
HORIZONTAL
SUPPORT

FLAT
SIMPLE
VALUES
THROUGHOUT

GOOD RELATING DARKS

SIMPLIFIED GROUND AREA

simple forms combined with strong value changes . . .

Analyzing the photo for areas and objects that can be simplified and rendered in flat values and colors is my first intention. The trees are easily handled as recognizable shapes, with the trunks represented in a series of negative and positive verticals in different sizes.

The ground area is broken up with oblique shapes that indicate depth without losing the feeling of a flat graphic representation. Other small flat areas, such as leaves, grass and fallen limbs, are also indicated in simple graphic terms. The leaves are also repeated in the upper half of the sketch.

For effective legibility, I limit the value change in all these shapes to about four distinct tones.

The simple forms and shapes can be easily described with the sketching pencil. With a few pencil strokes you can alter the negative and positive shapes and sizes of the trees. The light forms can be erased with the kneaded eraser. By varying the stroke pressure differences of value can be indicated; smaller trunks and lines can be done with the edge of the point.

The limited use of values makes for a sim-

the value sketch

Maintain the vertical theme throughout by repeating the perpendicular shapes. Give the theme all the emphasis you can if you want a strong visual statement.

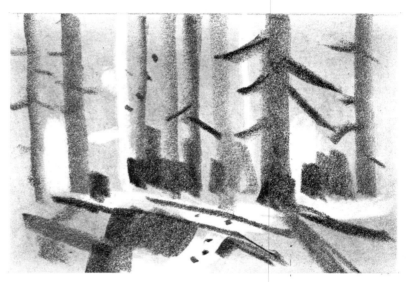

ple and effective painting. Simplicity and flatness are key factors in graphic representation.

As I have mentioned before, the value sketch is a good starting point. It can help solve many problems. Don't be afraid to change or alter in the interest of a better solution.

The darks are the sparks that make the whole design work effectively. Their placement can make a major difference in the final outcome.

Throughout the final rendering my constant concern is to maintain the upward thrust of the verticals of the trees while I establish an interesting variety in the values, colors and shapes throughout the entire design.

The soft green background wash of two parts olive green and one part raw sienna was painted first, leaving the white areas (the same sequence as in the value sketch). Next were the mid values of brown, an even mixture of burnt umber and burnt sienna, that suggested the background trees in a variety of sizes and values. This color is repeated in the foreground, in a darker value with the strokes implying cast shadows. The direction of these shapes suggests a sense of perspective and depth in the composition.

Lastly, the large dark tree trunks and foliage were painted using a mixture of three parts burnt umber and one part burnt sienna. A strong value difference in the tree area was maintained for maximum clarity. A few smaller pieces of calligraphy, such as branches, rocks and ground clutter, were added to enrich some of the large areas.

the completed painting

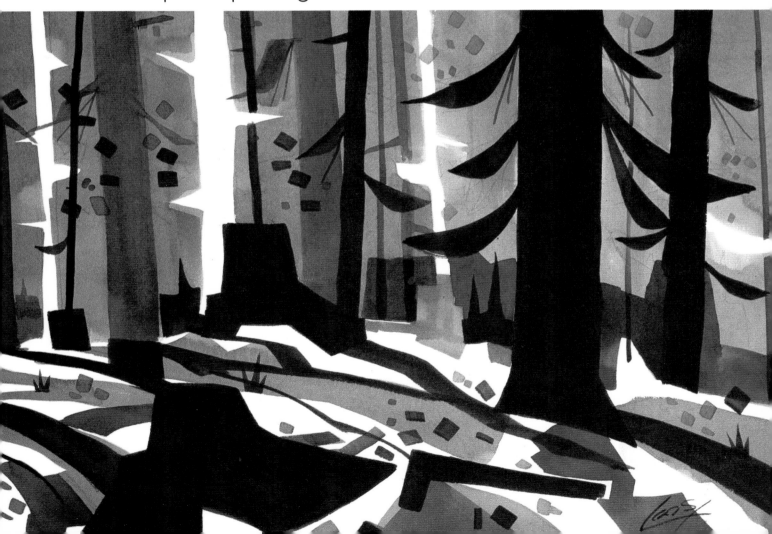

abstract

the subject analysis

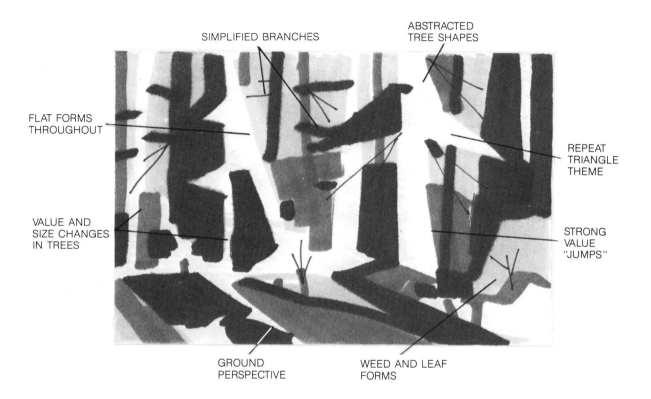

SIMPLIFIED BRANCHES

ABSTRACTED TREE SHAPES

FLAT FORMS THROUGHOUT

REPEAT TRIANGLE THEME

VALUE AND SIZE CHANGES IN TREES

STRONG VALUE "JUMPS"

GROUND PERSPECTIVE

WEED AND LEAF FORMS

work from the light areas . . .

Using the graphic demonstration as a starting point, I took the same forms and abstracted them to create the basic composition. The verticals and vertical obliques were altered with a more distorted geometric feeling. I decided on triangular shapes as a secondary theme to the perpendicular thrust of the trees. These occur throughout the design. In keeping with the rest of the composition, subordinate trees were designed in geometric form, with value changes to suggest depth and distance.

As in the graphic representation, perspective was indicated by the size recession in the ground shapes, all aided by strong value changes. I used calligraphy in the smaller branches and in the ground area. Care was taken to avoid monotonous repetition of sizes and shapes.

The subject analysis has helped define what to do, now I must decide where to do it. To create the design, I must first decide on the various sizes and values and how they relate to each other. Strong value changes must be designated for they affect the clarity of the whole painting. The tree shapes, the lights and darks, the foreground, all must be given the proper position and size if the composition is to work satisfactorily. As before, the

the value sketch

Make positive and sure pencil strokes for better legibility in the overall design. Shape, size, value and placement are most important in an abstract approach.

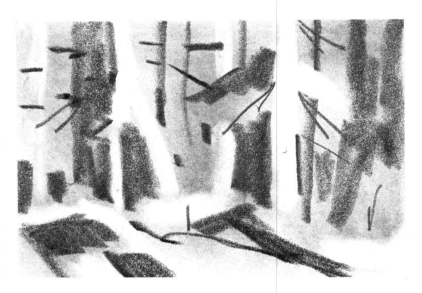

theme is to emphasize the perpendicular dominance modified by obliques.

The value sketch is the best means in determining these decisions. The quality of the finished work depends upon what is done here. So what better time to concentrate on clarity, value and size relationships and the total design of the painting to come?

In the final rendering, I think the values read clearly, the shapes are obvious and the theme and dominance of verticals are both maintained. The composition suggests forest without actually showing specifics. The basic color dominance is blue and cool, but a few accents of red were used for conflict. In the interest of design, *where* the red accents are placed, is more important than *what* they are. A red triangle at the base of the larger tree is repeated in the shape of the foliage. Red lines and squares are also repeated in the small trunk designations and the leaves.

The sequence of painting is similar to the graphic demonstration; the light blue background was painted in, leaving the lighter values in the trees and ground area. The dark pattern helps to play up the lights and midtones, and the entire composition possesses its own kind of unity.

the completed painting

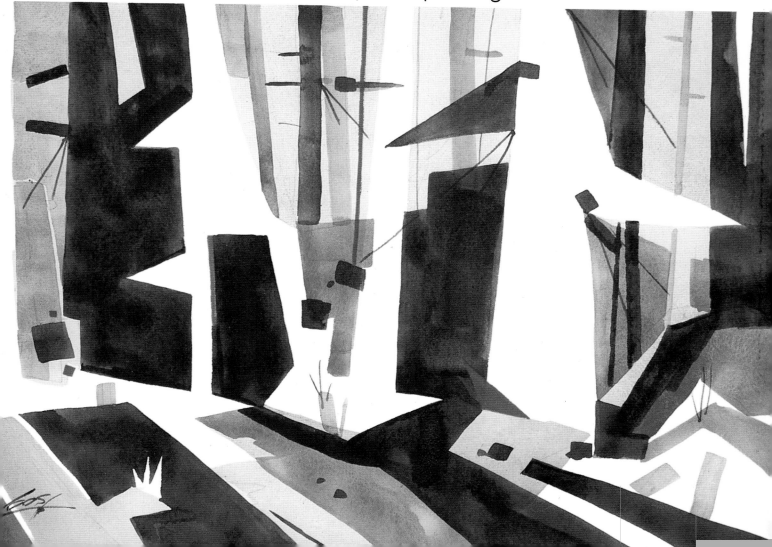

on gesso

the subject analysis

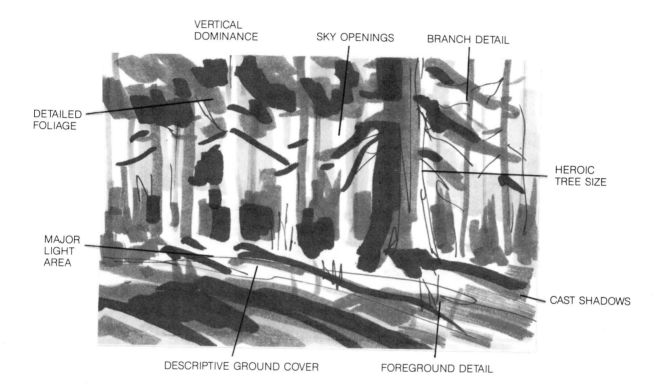

DETAILED FOLIAGE

VERTICAL DOMINANCE

SKY OPENINGS

BRANCH DETAIL

HEROIC TREE SIZE

MAJOR LIGHT AREA

CAST SHADOWS

DESCRIPTIVE GROUND COVER

FOREGROUND DETAIL

plan the relationships carefully

Analyzing the photo in order to render it on a gesso surface is almost identical to the preparation used in the traditional method. The design and composition follow the same patterns. However, the project is approached with the knowledge the painting will carry heavier pigment that can be otherwise removed and added more or less at will.

Again, enlarge the tree on the right to a more heroic size to create major size varia-tions. The other trees act as support players in the design of the entire work. The background lights are utilized to push the tree and foliage forward, providing an illusion of depth and perspective. The cast shadows show the ground contour and suggest the source of light. Since this is a more detailed style of painting, I am more attentive to the realistic aspect of the foliage, the branches, and the foreground growth.

Planning the design and composition is of primary concern as in the traditional manner, and is handled in much the same way. The light areas will attract the most interest, so their location is most important. At the lower left center of the composition I concentrate my significant light shape with smaller areas in the background repeating the light shapes. A word of caution here: do not use a dark area to interrupt a light pas-

the value sketch

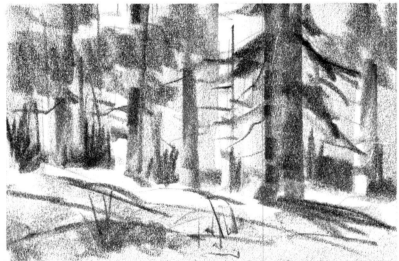

Treat the sketch with the same attention as in the traditional manner. Plan the locations of the trees, the light areas, and the relationship of one area to another.

sage without continuing that light on the other side. Notice the places where, throughout the background, the trees are silhouetted against the lights. In this way, a kind of rhythm is created that suggests movement without taking the emphasis away from the larger tree serving as the interest center.

The value sketch allows me to develop these areas early on to act as a reminder when doing the actual painting, and it saves me from having to make these decisions while occupied with the esthetics of color and overall appearance.

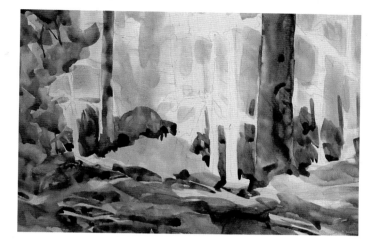

This stage will show the initial character of the pigment when applied to the gessoed surface. Note the crawling and puddling effects. Don't be too concerned, because it will be possible to work these areas later with pressured brush strokes. This is the time when the space relationships are established in the shapes, the sizes of the trees, and the contours of the ground areas.

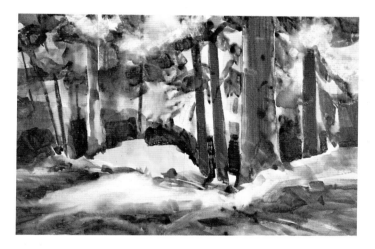

Here I have added pigment to solidify the forms, and have wiped out more light areas in the foreground. As mentioned before, this is done quite easily, since the paint is simply lying on the surface and can be removed with a sponge or lifted with the thirsty brush.

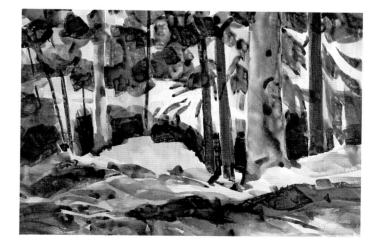

As you can see, a better blending of colors is obtained by brushing into the heavy pigment. Texture begins to appear at this time giving an altogether different appearance to the work. More darks are introduced, accenting the lights and midtones. This method takes more time than the traditional way because of the repeated strokes necessary to control the pigment.

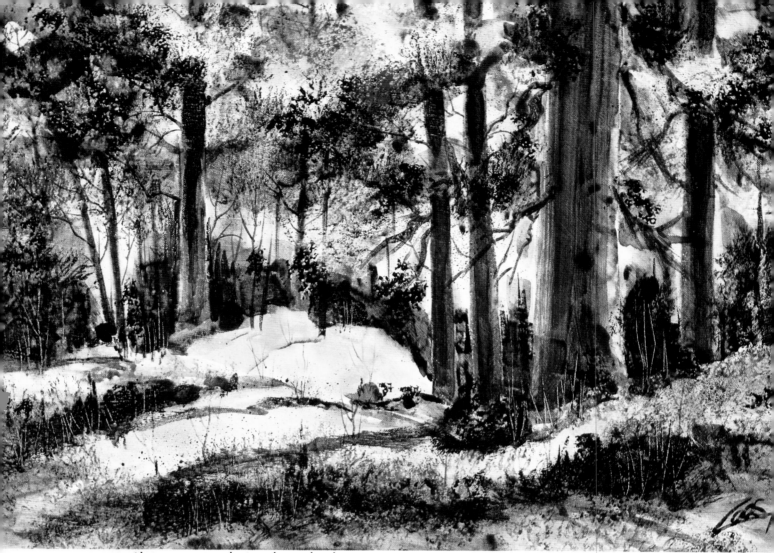

the completed painting

Since more painting time was required, and more concentrated pigment was used, the final work has a heavier appearance, almost as if done in oil or acrylic. This is further evidenced by the textural quality of the gessoed paper. The ability to change or "edit" this type of painting can be seen by comparing the first stage on the previous page to the final result shown above.

In keeping with the subject, the dominant dark color is green: a thick mixture of three parts olive green, one part each of raw sienna and cobalt blue. Olive green has several characteristics I like: First, it does not contain stain pigments, so the wipe-outs leave the gesso surface clean. Second, it blends well with other pigments. Mixed with

cobalt blue, a cool dark is made; mixed with raw sienna, a warm dark. My light areas are cadmium yellow mixed with a small amount of olive green. The tree trunks are a combination of burnt umber and cobalt blue.— (Use more cobalt blue to cool, or more umber to warm the trunks.) Warm areas in the foliage and foreground are burnt sienna right from the tube.

By spraying areas with water from an atomizer, the pigment becomes more pliable and small grass and twigs can be delineated by scraping with the point of a kitchen knife or palette knife. Wetting the pigment and tamping it with a tissue provides texture to the rock surfaces, tree trunks, and foliage.

chapter five the floral

subject V

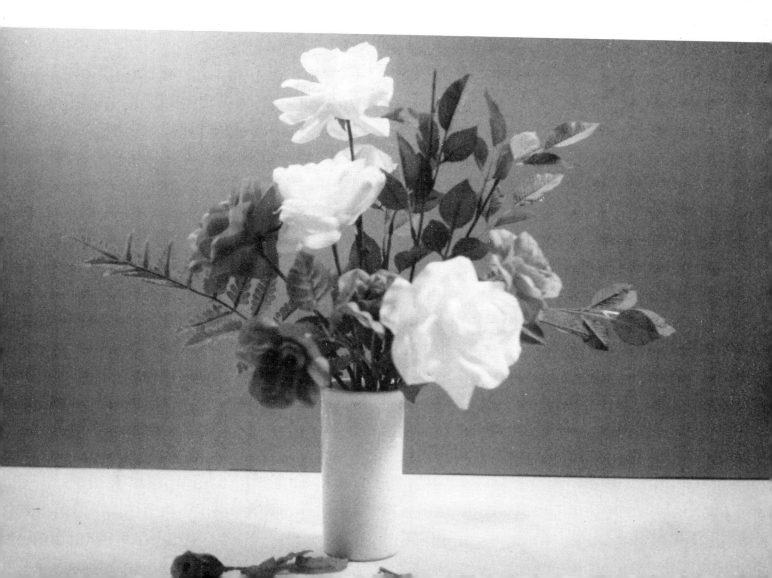

traditional

the subject analysis

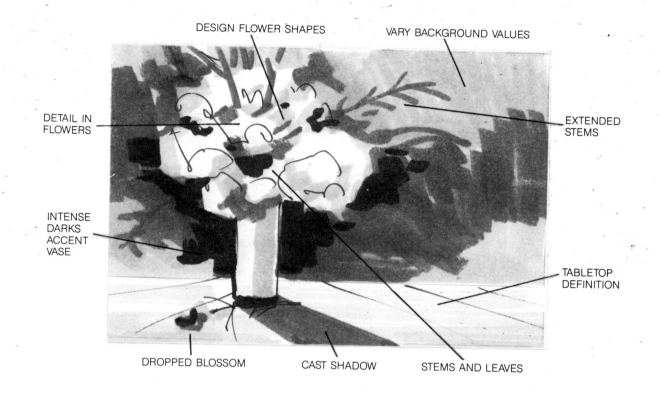

DESIGN FLOWER SHAPES

VARY BACKGROUND VALUES

DETAIL IN FLOWERS

EXTENDED STEMS

INTENSE DARKS ACCENT VASE

TABLETOP DEFINITION

DROPPED BLOSSOM

CAST SHADOW

STEMS AND LEAVES

good relationship in size, value and color . . .

In analyzing the photo of the floral, I see the position of the vase of flowers as too centered, so I'll move it slightly to the left. The background is monotonous in value, and requires major changes. This is best accomplished by intensifying the values around the vase and by moving the darks from lower to upper right. This provides a good background for the floral arrangement and accents the bright colors of the blossoms. (When painting flowers try to make them *soft, colorful,* and *fresh* looking.

The flower shapes have to be incorporated into a design that relates well with the total picture area. Also make certain the flowers vary in their attitude; head-on, three-quarter, and profile, and show them in different sizes, colors and values. The stems and leaves provide the calligraphy.

The softness of the subject can be described with smudged graphite. The light areas are easily picked out and with the darks added, a good design can be created.

the value sketch

The information gained from the photo analysis enables me to compose the value sketch into a better arrangement. First, I design the shape of the flower area to make certain it is dynamic, oblique, wider than it is high, and with interlocking edges. I then emphasize this shape with the dark value changes in the background. The tabletop provides a base for the vase with the cast shadow showing the form of the table. The dropped petals of the flower repeat the horizontal attitude and help to break-up the empty space. Leaves and stems are added for detail and calligraphy.

Care must be taken to keep a soft, but fresh, feeling throughout. This is achieved by blending the values at the edges of the forms. Actually, the only hard edges will be in the sides of the vase, which acts as contrasting support for the large indefinite shape of the flowers.

Does the completed work have the desired soft, fresh and colorful look? I believe it does. The flowers present happy, colorful shapes, and seem fresh and soft. Since the background and foreground are neutral they support the subject without interference. The background has value change, and accents the subject matter; the leaves and stems add necessary interest with their distinctive calligraphic character. The color and directional change in the tabletop gives a counter-move to the rest of the composition.

The result: a representational flower painting, planned to illustrate the essence of flowers; their color, their softness, and their freshness.

the completed painting

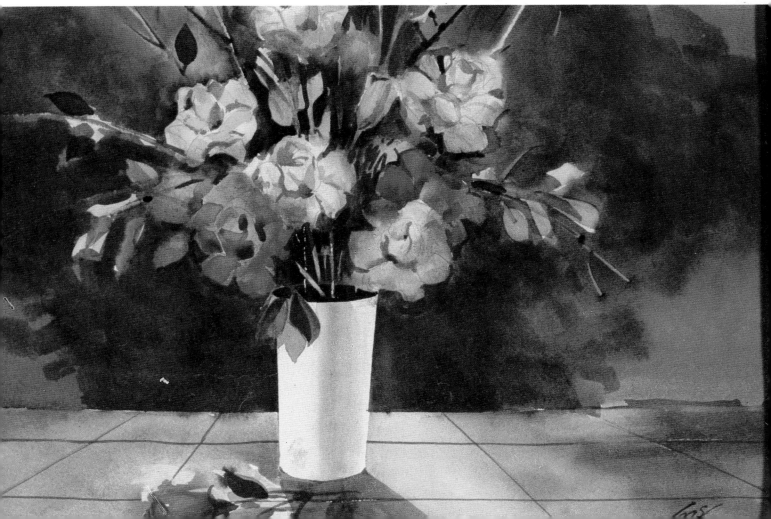

calligraphic

the subject analysis

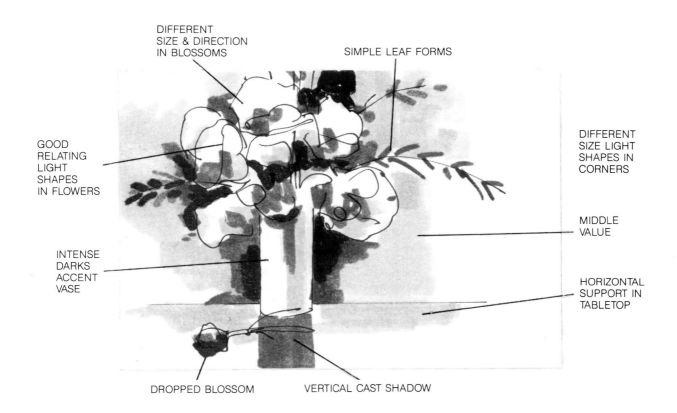

DIFFERENT
SIZE & DIRECTION
IN BLOSSOMS

SIMPLE LEAF FORMS

GOOD
RELATING
LIGHT
SHAPES
IN FLOWERS

DIFFERENT
SIZE LIGHT
SHAPES IN
CORNERS

MIDDLE
VALUE

INTENSE
DARKS
ACCENT
VASE

HORIZONTAL
SUPPORT IN
TABLETOP

DROPPED BLOSSOM

VERTICAL CAST SHADOW

pre-planning is a time-saver!

To create a calligraphic effect I can eliminate most of the background, leaving just enough to support the flower shape and the vase. I'll shorten the length of the tabletop and position the vase left of center. Directional and perspective lines will be added to the top of the table.

The flowers will be suggested as simplified forms. Little detail will be shown, since I will concentrate mostly on shape, value, and size relationships of one form to another. The stems and leaves will be indicated by single pencil strokes.

The flowers should be repeated, so a single, dropped blossom is added, which dresses up the foreground and helps create interest.

I let the large flower shape extend out of the painting to suggest more height and to make a more impressive design. Small blossoms and buds are indicated to avoid monotony in the flower forms.

Spontaniety and freshness can be obtained in the value sketch by the "picked-out" lights and by accenting them with darks. Indicate the small areas with the pencil edge.

the value sketch

The worth of the value sketch is never more apparent than in the planning of a flower rendering. Should I attempt to paint directly on the white paper, much time could be lost while trying to design the composition as I go along, with disaster waiting for me every step of the way. The comfort and confidence that the value sketch affords, makes all the planning and effort worthwhile.

In doing the value sketch of the calligraphic floral, I plan the location of the large middle value area in the picture area carefully leaving various sized shapes of white in the corners. These light areas are repeated in the group of flowers with accents of intense darks. The overall flower grouping is decorated by the outward movement of the leaves and stems. The foreground space is broken by the location of the dropped blossom. The vase (another light section supports the mass of flowers, leaves and stems, and is accented by the darks surrounding it. As a counter to the long horizontal of the tabletop, I give the cast shadow of the vase a dark vertical form. I am now ready to transfer the drawing on to the watercolor paper and proceed with the final painting.

Fresh! Soft! Colorful! The flower basics are exemplified and brought to life in the final painting. A soft lavender background of four parts cobalt blue and one part alizarin crimson, supported by a warm wash of raw sienna in the foreground, offers excellent color and value support to the large flower shape. The blossoms are varied in size and brilliant color—cadmium red light muted by alizarin crimson, and cadmium yellow light with raw sienna for form description. These colors were used right from the tube with no mix-ing. The small white flowers are tempered with the lavender wash. The stems and leaves are a combination of three parts olive green, one part cobalt blue and one part raw sienna, varied in value, size and shape.

The corner areas of white paper are all different, since it is just as important to design the negative forms as the positive ones. A static shape is boring and uninteresting, so I try to avoid equilateral triangles, squares or circles in my compositions. One bad shape can spoil the entire painting.

the completed painting

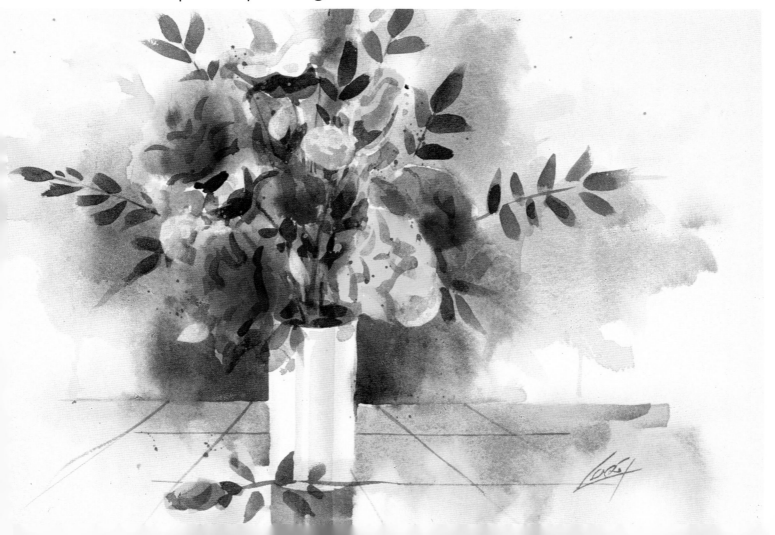

graphic

the subject analysis

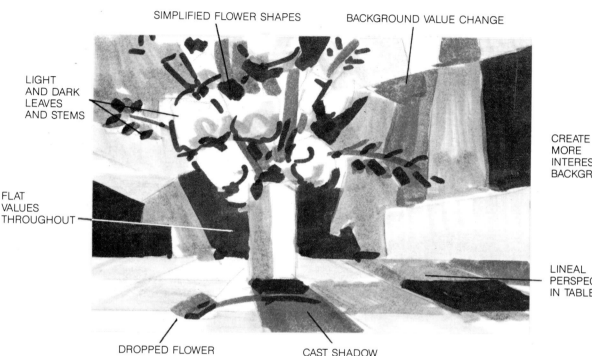

SIMPLIFIED FLOWER SHAPES

BACKGROUND VALUE CHANGE

LIGHT
AND DARK
LEAVES
AND STEMS

CREATE
MORE
INTEREST IN
BACKGROUND

FLAT
VALUES
THROUGHOUT

LINEAL
PERSPECTIVE
IN TABLETOP

DROPPED FLOWER

CAST SHADOW

think two dimensional . . .

The possibilities for a graphic rendering of flowers are limitless. Every shape should be presented in a flat form modified by other flat forms. Many flowers, being round in nature, can be described in curved shapes controlled by flat values. Perspective is obtained by directional lines—as in the tabletop.

My first move is to decide the relationship of curves to straight areas. The curvilinear flowers will be accented by the severe lines in both the background and foreground. The straight sections act mostly as a backdrop for the star of the show—the flower mass. The background will be rather non-committal, but the foreground must show support for the subject, so perspective is suggested with the recession of the rectangles in the tabletop, while varying the values and colors.

The positive and negative leaves and stems are used to stimulate interest in the flower area, and indicate form in the blossoms with only three values to keep them as simple as possible. The two-dimensional vase counteracts the strong horizontal flow of the table top.

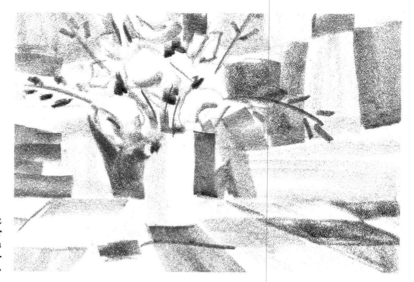

As with other graphics, the flat sketching pencil is ideally suited for presenting flat forms. Variations in pressure results in a crisp, well-defined design.

the value sketch

Knowledge of the subject is of great help in converting the traditional forms into a graphic style. It helps to know how to paint flowers effectively before you can represent them well in a flat form. I use the essence of each section as a beginning. The background which is monotonous in the photograph, is indicated as a series of flat, interlocking and well-related forms, designed only as a backdrop for the subject. The simplified curved forms of the flowers offer conflict to the background and foreground straight emphasis. The checkerboard foreground shows perspective, value and color change, and provides a support for the vase and flowers.

The background values determine the negative and positive forms of the leaves and stems. These small sections of value should read well against the large, flat shapes.

What seems to be, at first glance, a hodge-podge of unrelated values, colors and shapes, quickly develops into a comprehensive, and well-related design. A good interplay of lights, darks and midtones will allow the shapes to read well and present the painting successfully in graphic form. There are no traditional formulas that will help.

I've strayed only once from the traditional flower approach. They are colorful and fresh, but no softness is indicated, since it does not seem necessary in pure design. Soft edges would tend to destroy the unity of the work, and unity is an important design principle.

the completed painting

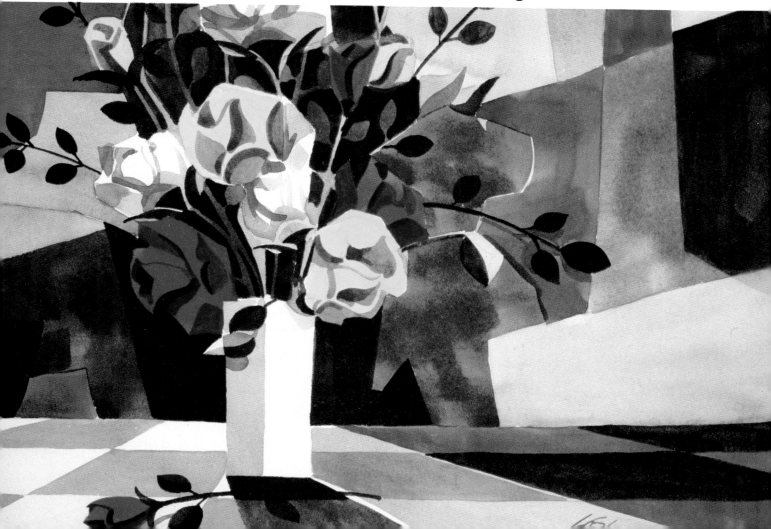

abstract

the subject analysis

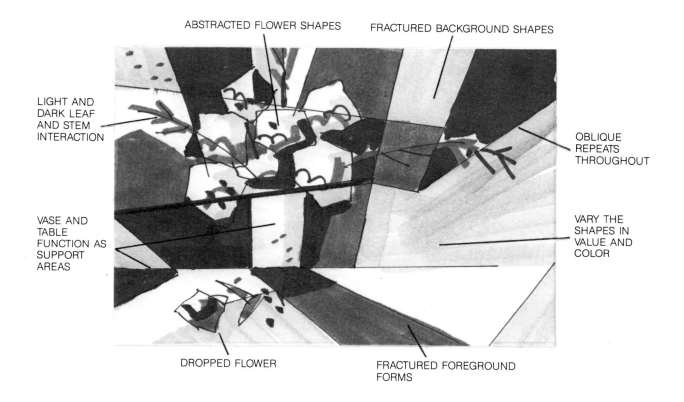

ABSTRACTED FLOWER SHAPES

FRACTURED BACKGROUND SHAPES

LIGHT AND
DARK LEAF
AND STEM
INTERACTION

OBLIQUE
REPEATS
THROUGHOUT

VASE AND
TABLE
FUNCTION AS
SUPPORT
AREAS

VARY THE
SHAPES IN
VALUE AND
COLOR

DROPPED FLOWER

FRACTURED FOREGROUND
FORMS

the dark areas make it sing . . .

Although there is enjoyment in working abstractly, you must exercise caution when planning the painting. Certain rules, used in all styles of painting, must be observed in order for the end result to read as a unified whole. Color, size, and value relationships have to work effectively in the design. The fun comes in the defining of familiar shapes and forms into abstract shapes. The final form has to say "flowers" without *being* "flowers" in the traditional or academic

sense. The leaves, stems and vase must be treated in a similar manner.

I like to plan my light shapes carefully—their readability, value and location are always important to the design. From the light areas, I key the midtones and darks, and create forms that allow the subject to be identified, even in their abstract forms. The smaller shape collection in the flowers is accented by the larger flat abstracted shapes in the background.

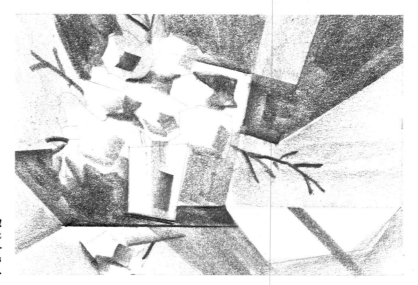

I allow my creativity to run wild! This is experience and knowledge at work. I observe the basic rules of design, but distort and abstract as much as I want.

the value sketch

As a preview to the final work, I utilize the value sketch to arrive at the basic decisions regarding shape allocation, value and line relationships, and an overall concept of the design. The oblique lines serve as eye directors toward the interest portion of the painting—the flowers. These lines also help in developing the larger abstract shapes.

My concept, as usual, begins with localizing the light shapes and how they relate to the whole composition. These shapes, of course, must be in abstract form, and may suggest directions and value relationships of other forms. The lineal divisions are excellent to work from, since they can suggest positive or negative value, and color "jumps", as in the leaves, stems and vase. The form is only suggested and not reported literally as in the traditional approach.

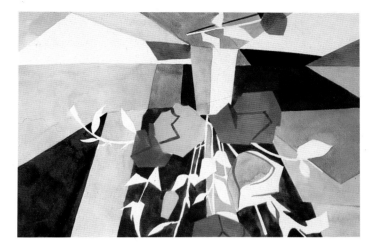

The painting is reaching the final stages. Form is indicated by the lineal strokes in the blossoms. Cool middle value shapes are added to top right center and lower right center, to enhance the remaining light areas. Minor darks are added to the bud bottom center. From this point, repeats of color are all that are needed to complete the painting.

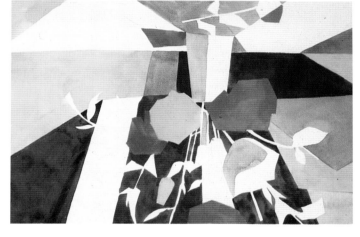

Additional darks are added to indicate leaves and stems, top left center. The large white shape lower right is altered by the introduction of light value forms. This value is also repeated top left and in the large center blossom and bud at top center.

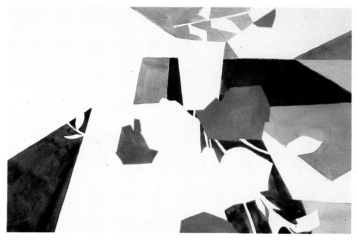

The large light areas are established by the use of oblique lineal and value subdivisions. The flower shapes are indicated and related in value, leaving the negative shapes of the leaves and stems as lights. Value and shape relationships are determined with care.

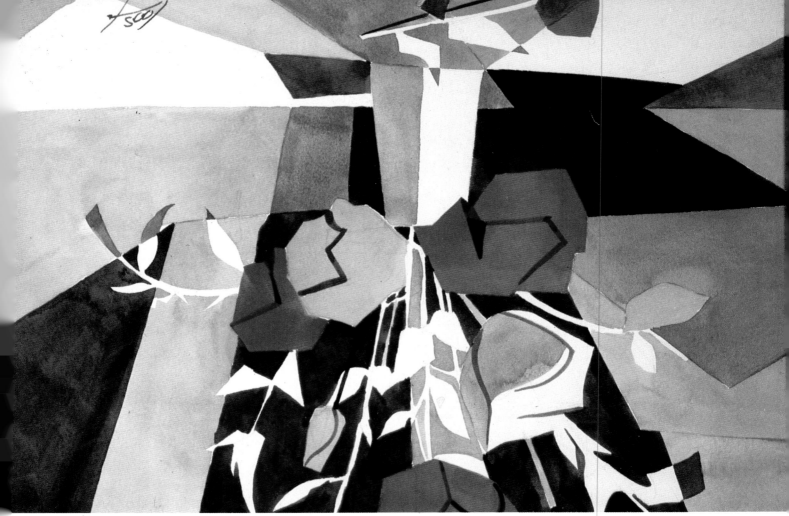

the completed painting

All the preliminary work, the subject analysis, and the decisions made in the value sketch, have enabled me to do this painting with a great deal of assurance. There was little hesitation as to what my aim was, since major decisions were made earlier as to shape, value, and line allocations. This left only the color choices to make. This was not too difficult because I knew that the flowers would be basically red and yellow. From this point, it was a question of relating these colors to the rest of the work and making them read effectively.

The remaining areas in the background were divided into a variety of shapes, relating to each other in size, value and color. Large shapes were placed against small ones, dark values against light values, and cool colors were contrasted with warm colors. As is my habit, I try to start with just three or four basic colors (three cools plus one warm, or three warms plus one cool). In this case three warms are cadmium red light, burnt sienna, cadmium yellow light. Cobalt blue was used for the cool conflict. Using the colors pure or mixed with each other, produce a closer harmony. (You'll find this color plan works well with most painting styles.)

on gesso

the subject analysis

VARY FLOWER SIZES AND DIRECTIONS

LEAF AND STEM INDICATIONS

ALTER BACKGROUND VALUES

GOOD SHAPE IN FLOWERS

LEAVES AND STEMS PROVIDE OUTWARD MOVEMENT

VASE JOINS FLOWER FORMS WITH TABLETOP

LINEAL DIRECTION IN TABLETOP

DROPPED BUD

INTENSE DARK

CAST SHADOW

photo values can help at the start . . .

Since the subject photo analysis of the gesso floral is almost identical to that used in the traditional style, I felt this space could be devoted to a fuller explanation of the use of photographs in painting creatively. I'm also including my personal views along with a discussion of their use in practice.

I find working from a black-and-white photo is a good way to begin painting in my studio. I can exercise my artistic prerogatives by altering or changing the photo into a more interesting composition. Since value relationships are important, the black-and-white photo is useful in training the eye to see pleasing shapes, without being distracted by color influence.

A color photo might result in a less creative painting because you could be influenced by the colors you see and tend to copy them rather than be inventive with your own color selection.

Since the photos I use have been taken either by my wife Dianne, or me, I will use them as reference material. It is advisable to use your own photos when painting for sale or for a competition.

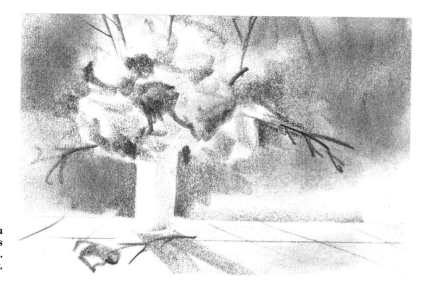

The light shape is the key—where you place it and how you accent it—is most important to the composition. The long horizontal provides stability.

the value sketch

The drawing sequences in my value sketch are generally followed in the finished painting. In the sketch, I lift out the lights from the midtones and accent them by the placement of the darks. Over the years, I have made this a sketching habit that continues to work well for me in countless paintings.

The sketch is my plan; it's the basic course of action toward a more satisfactory painting. Without it, I could sink in a sea of indecision. Since I wish to avoid this, I do not put pressure on myself by rushing the sketching phase. Working with the sketch on location helps me to isolate the subject without trying to paint everything in sight. I usually sketch the scene, turn my back to it, and paint from my interpretation of the subject. Occasionally, I may take a quick look to confirm a detail, color or shadow, but I rely on my sketch for basic composition and values. This method frees me from being overwhelmed by inconsequential details and distractions, and helps to keep me from being *too* literal and factual.

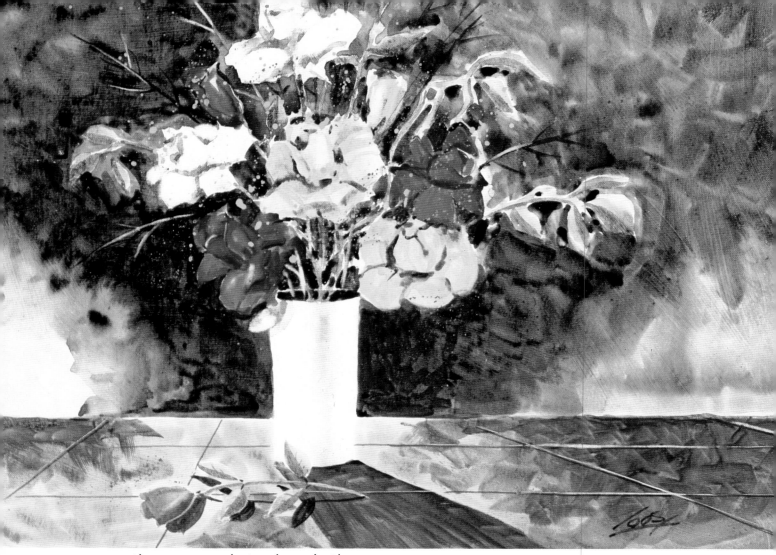

the completed painting

As mentioned before, the gesso surface I use is versatile, so some things that are not possible on regular watercolor paper, can be accomplished when working on this surface. The lifting and wiping out can rescue an unsatisfactory area which, in a traditional painting, would be difficult, if not impossible, to repair. Many students find this type painting to be a great confidence builder, and they are apt to attempt subjects which they normally would lack the courage to try. They feel reassured in the knowledge their mistakes can be altered or removed.

I used the same sequences here, as in previous value sketch description, with one deviation: The background was painted first, leaving the light shapes of the flowers. Then,

the darks were introduced to emphasize the light forms, after which I painted in the flower colors, and modeled them by lifting and repainting.

The foreground support area was defined with the cast shadow and the lines in the tabletop.

The background color is about three parts dioxazine purple, combined with one part burnt sienna. A mix of four parts raw and one part burnt sienna formed the tabletop. Flowers, varied in value, are pure cadmium red light and cadmium yellow light, accented with pure raw sienna and alizarin crimson. Leaves and stems are olive green and cadmium yellow light.

subject VI

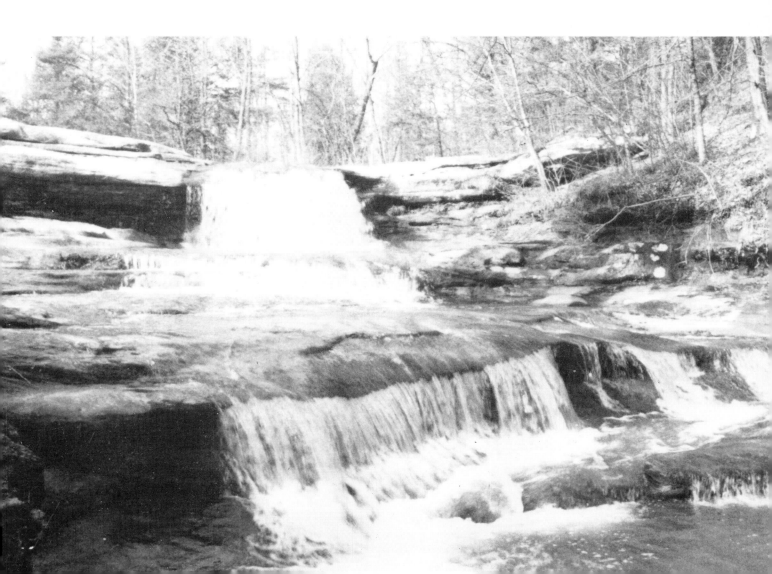

traditional

the subject analysis

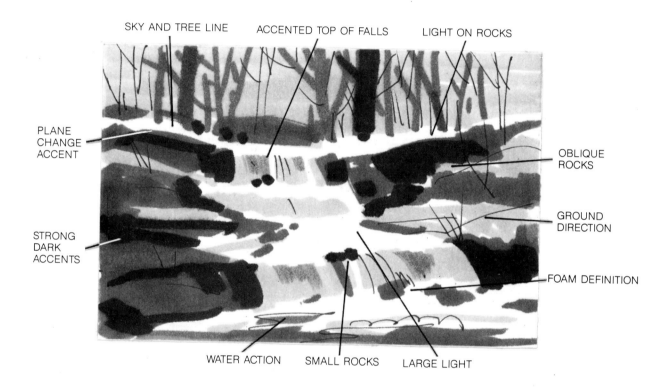

SKY AND TREE LINE ACCENTED TOP OF FALLS LIGHT ON ROCKS

PLANE
CHANGE
ACCENT

OBLIQUE
ROCKS

GROUND
DIRECTION

STRONG
DARK
ACCENTS

FOAM DEFINITION

WATER ACTION SMALL ROCKS LARGE LIGHT

look for the light shape

This waterfall has a characteristic that may be used to a painter's advantage—a good well-defined oblique light shape. Its form suggests perspective, and the rushing water generates movement and interest. The darks in the shoreline and ground areas, and the middle values of the rocks, provide accents necessary to enhance the light areas. Strong diagonals in the shoreline and ground forms are countered by the horizontal sky and the quieter water at the base of the falls.

To capture the illusion of falling water in your painting, it is helpful to accent, with strong contrasting values, the area where the stream cascades downward in its near vertical fall. The abrupt change in plane in the direction of the water, ending in the white foam and rocks at the base, is sure to generate a powerful center of interest.

In the value sketch, I use a variety of darks to help define the large oblique light shape in the falls, which, in combination with the light shapes of the horizontal sky and foreground water, creates an interesting light path. These areas are all accented by the darks in the silhouetted trees, the rocks along the falls, and the horizontal water movement and rocks in the pool at the base.

Subtle value changes can be suggested by rubbing the graphite sketch with the finger or a small piece of cotton or cotton swab.

Calligraphy is added in the forms of small rocks, tree branches, and foam description to finish off the sketch.

the value sketch

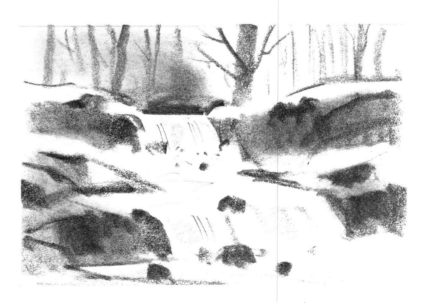

Practice with the sketching pencil gives you more speed and facility, making your sketches more spontaneous and fresh. This, in turn, will carry over into your paintings.

Sharper divisions of value are evident in the final painting, and the large light shape of the waterfall has been emphasized by the surrounding dark rocks and ground areas. While the pigment was still wet, the rocks and ground contours were scraped out with the pot scraper, (see page 19) creating light planes on the top surfaces of the rocks and directional movement in the ground areas.

Water flow is defined by the midvalue movement in the light area. By accenting the horizontal light at the head of the falls, a more convincing effect of falling water is achieved.

The darks are a mix of two parts burnt umber, two parts burnt sienna and one part cobalt blue. The color of the water is a wash of one part olive green, two parts cobalt blue and a touch of raw sienna (I prefer raw sienna to yellow ochre because of its transparency). In the darker areas, foliage is a combination of three parts olive green, one part cobalt blue and one part Payne's gray.

the completed painting

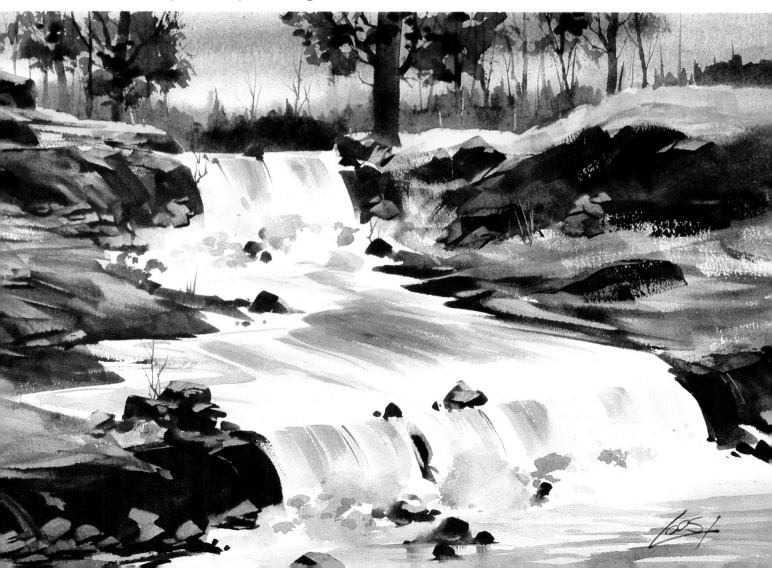

calligraphic

the subject analysis

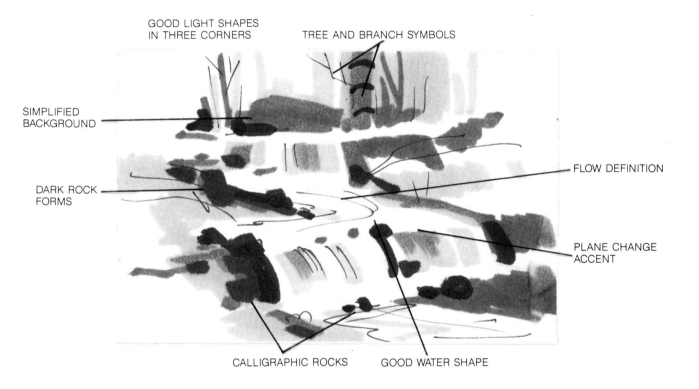

GOOD LIGHT SHAPES
IN THREE CORNERS

TREE AND BRANCH SYMBOLS

SIMPLIFIED
BACKGROUND

DARK ROCK
FORMS

FLOW DEFINITION

PLANE CHANGE
ACCENT

CALLIGRAPHIC ROCKS

GOOD WATER SHAPE

single strokes for a positive look . . .

Try to eliminate the superfluous information and concentrate on those things that say "waterfall"—the rushing descent of the water, the rocks that disrupt its movement, the quiet water at the base. I start by placing a large middle value shape on the paper, making sure I leave dissimilar white shapes in the corners. These, combined with the large light waterfall shape aid in the overall de-

sign. The subject should read clearly with the supporting darks assuming major importance by their location. The trees offer a vertical conflict to the strong obliques in the falls and ground areas.

Calligraphy is introduced in the rocks, foliage, ground growth and the smaller trees. Some lineal definition in the ground areas provides detail and texture.

Information gathered from the subject analysis allows me to proceed with the value sketch as to shape allocations, where the accents should be applied, and how the subject can be emphasized, without losing the integrity of the design.

Water movement is the essence of a waterfall and this is emphasized by the oblique and circular patterns that create action in the large light area. This is further accented by the rigid, unmoving forms of the dark rocks and other parts of the ground. Note that there are curves being repeated in the foliage. Calligraphy adds variety and texture. The addition of a distant hill gives depth to the composition.

the value sketch

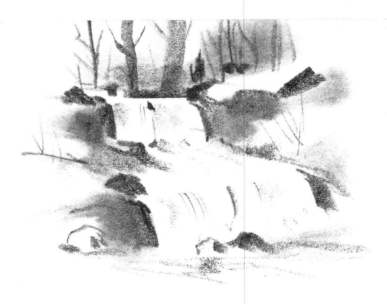

Subtle value changes can be suggested by rubbing the graphite with a finger. More positive forms are added with direct pencil strokes.

One of the objectives of this painting style is to use a minimum of brush strokes, take advantage of the transparent colors to create beautiful and different combinations of washes. As much white paper as possible is left untouched to create a feeling of light and sparkle.

Underpainting in yellow, green and brown washes gives a warm glow to the rather colorless forms in the ground and water areas. Lavender in the distant hill is also repeated in the middle and foreground.

The three white vignette corners are of different size and shape, thereby avoiding dull and repetitive areas. Try to maintain interest throughout the whole picture by creating interesting relationships between each shape in value, size and color.

To complete the painting, smaller trees with their branches were added with the #6 rigger brush.

the completed painting

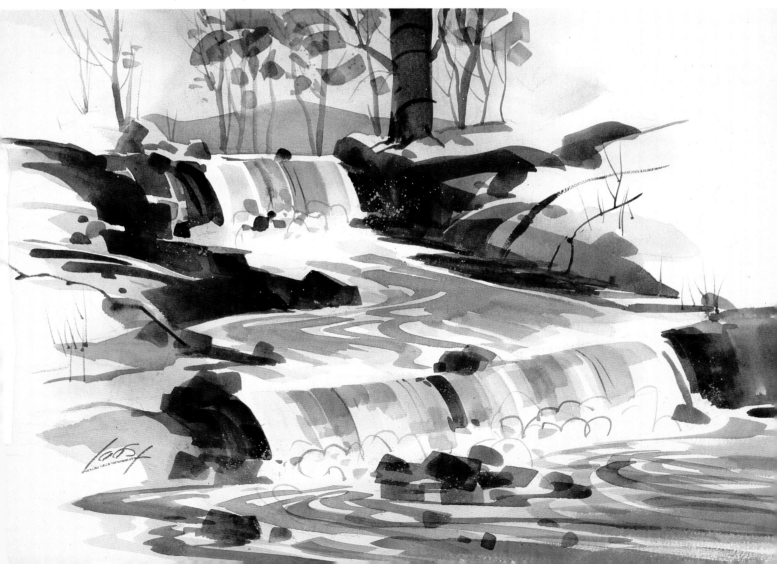

graphic

the subject analysis

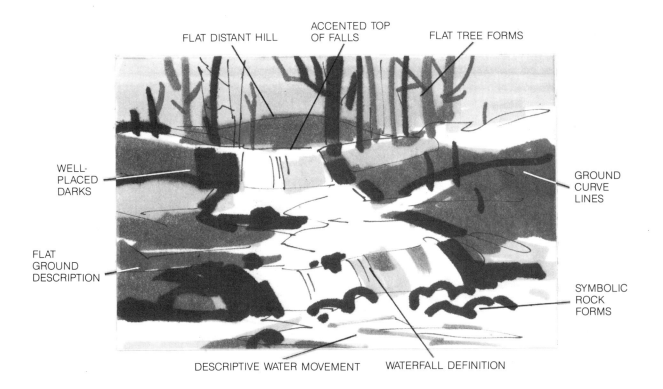

FLAT DISTANT HILL

ACCENTED TOP
OF FALLS

FLAT TREE FORMS

WELL-
PLACED
DARKS

GROUND
CURVE
LINES

FLAT
GROUND
DESCRIPTION

SYMBOLIC
ROCK
FORMS

DESCRIPTIVE WATER MOVEMENT

WATERFALL DEFINITION

good relationships support good design

Translating the traditional to graphic
sharpens the eye for design. The challenge is
how to convert traditional three-dimensional
forms into a series of effective flat graphic
shapes. The sky, ground, and water areas,
and trees and rocks are represented by flat
values. Form is suggested by the strategic
placing of both straight and curved
directional lines. Oblique movement and

direction in these flat forms suggests depth.
Throughout the planning, I concentrate on
the relationship between the various shapes
by their values, sizes and directions.

Action is achieved in these larger areas by
the introduction of calligraphy. Curvilinear
passages and lines help modify the many
straight and oblique areas in the overall de-
sign.

Flat! Flat! Flat! Purposeful avoidance of traditional treatment with its attendant value subtleties is a must in the graphic presentation. The key to a good graphic painting is to use flat shapes in various values and sizes, with descriptive lineal directions and divisions. I concentrate on these relationships, big to little, curved to straight, obliques to verticals and horizontals. Such opposition and varieties are always important in producing the desired result.

The subject is emphasized by the shapes surrounding it. These shapes are the controlling factors in the clarity of the subject's form and its identification. With these passages defined, the calligraphy and lineal work are applied to provide legibility in the larger areas. They show the areas of activity in the water, the slope of the ground, the trees, and the small pieces of rock that give interest to the bigger forms.

the value sketch

Strong, authoritative strokes of the pencil can make a clear, graphic statement. Use the broad point for the larger forms, the edge to suggest the lineal and calligraphic indications.

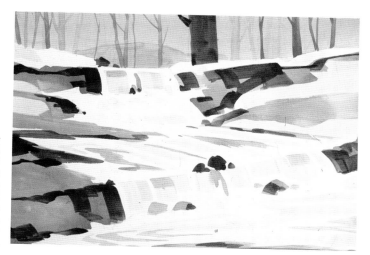

Since a waterfall is best illustrated by emphasizing the drop area, I work around this white section of the painting with dark values. I show perspective and movement in the water and falls by the gradation in size and value of its shape from foreground to background. This is also obtained by the diminishing sizes of the rocks and trees. Monotony in the sky areas is avoided by varying values and sizes in the trees.

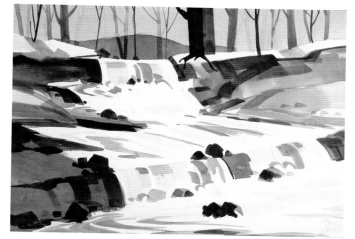

More trees area added and larger darks help define the water. The break at the top of the falls is emphasized by the plane change from horizontal to vertical. Water is indicated with a variety of different brush-strokes; as in the falls, the flowing water, and the quiet water at the base of the falls.

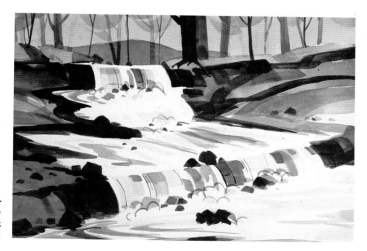

A soft, curved accent is added in the foliage description. Foam at the base of the falls is illustrated by a curved repeat in the water.

This graphic painting is done with dominant brown with green accents. Flat forms without gradation are evident throughout the sky and ground areas, the curves of the foliage, and in the smaller rocks. Even the description of the falling water is accomplished by a series of curved, flat vertical strokes. Other water activity is suggested by the oblique flow of the water. Note that the circular indications of foam are repeated in the foliage.

The brown is three parts burnt sienna mixed with one part dioxazine purple, and with one part Payne's gray, added for more intense darks. The greens are washes of three parts olive green combined with one part cadmium yellow light.

the completed painting

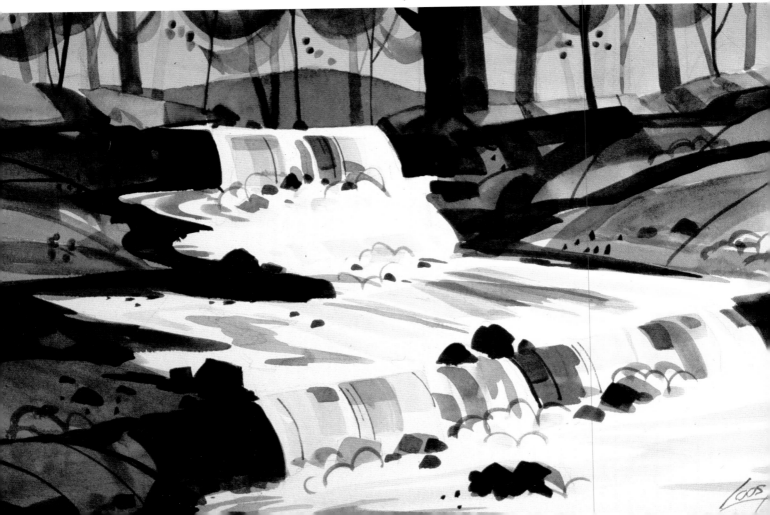

abstract

the subject analysis

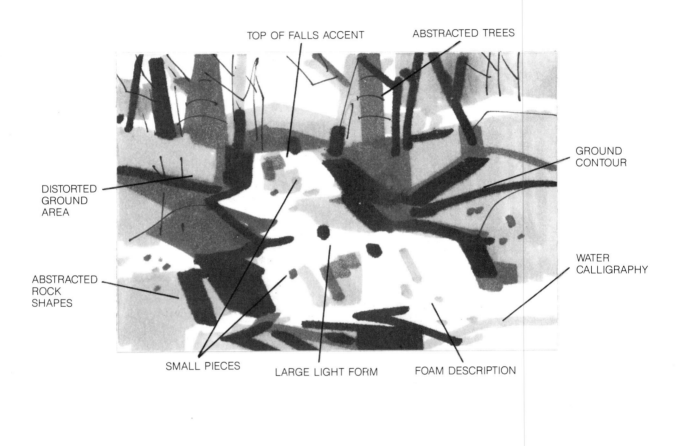

TOP OF FALLS ACCENT

ABSTRACTED TREES

GROUND CONTOUR

DISTORTED GROUND AREA

WATER CALLIGRAPHY

ABSTRACTED ROCK SHAPES

SMALL PIECES

LARGE LIGHT FORM

FOAM DESCRIPTION

alter your thinking—be different!

Abstracting the waterfall allows me to take liberties with the subject, while bearing in mind that there has to be a slight bow to the real. Distortion is necessary, but only to the degree that the shapes must all come together later on to present an image that is still recognizable.

The light area is usually my starting point, so first I define it with surrounding dark abstracted shapes that not only create a path for the descending water, but also abstract the light shape of the water. Smaller distorted rocks and indications of moving water are located in this area. As in the traditional approach, horizontal surfaces are shown to be lighter to accent the darker values of the vertical forms. Trees are shown flat and distorted, with interplay between the trunks and the ground area. I emphasize the top of the falls with a strong dark that suggests a distant mountain.

First of all, I define that all-important light shape, then indicate the dark areas that will provide suppport and emphasis to that light shape. I am careful in abstracting these forms because I want the viewer to recognize the subject and to become involved and be entertained. After I have located all of the large shapes, my next step is to introduce some identifying calligraphy in the form of directional lines, with smaller and more descriptive marks to add texture. These areas have to carry the design, since they are what the viewer relates to in his or her identification of familiar and recognizable shapes.

the value sketch

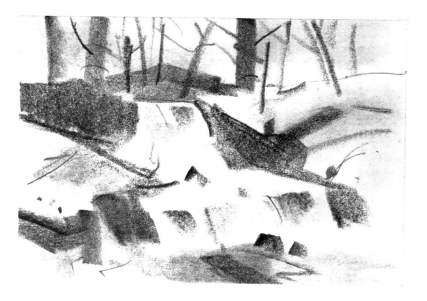

Value differences affect the clarity of the work, so be strong and positive in your sketch. What you do here is important to the final effect.

In its final form, the abstraction should read loud and clear. The strong values are complemented by the lighter ones, and unrealistic colors are deliberately used to emphasize the abstract feeling. The large light shape says *moving water,* and is identified as such by the calligraphy. Distant hills provide a backdrop for the scene; their colors and shapes repeated in the foreground. Bright areas of color are repeated in strategic locations to add excitement to the design. The rhythmic foam adds activity to the water area and a curvilinear conflict to all the straight lines. Such a painting can be a most enjoyable exercise.

the completed painting

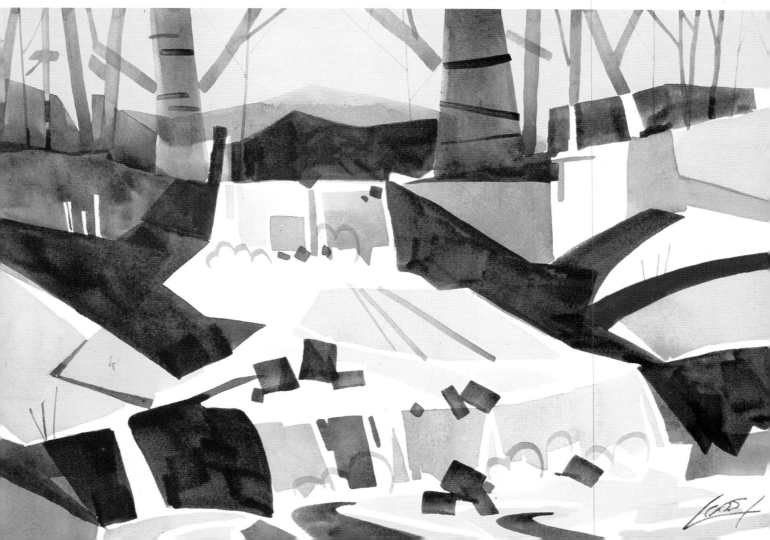

on gesso

the subject analysis

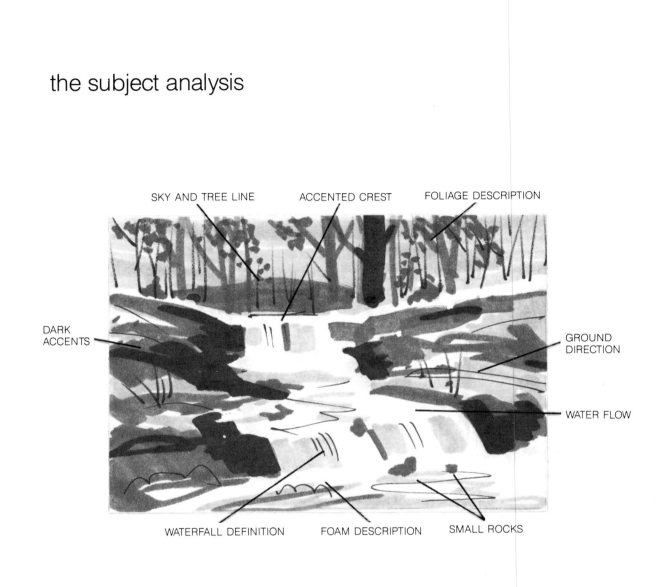

SKY AND TREE LINE ACCENTED CREST FOLIAGE DESCRIPTION

DARK ACCENTS

GROUND DIRECTION

WATER FLOW

WATERFALL DEFINITION FOAM DESCRIPTION SMALL ROCKS

knowledge of the subject is essential . . .

Examine the photo with the same end in mind as with the traditional style. The painting should reflect good design and knowledge of the subject. The basic shapes and values have already been validated in the traditional example, so my aim is to utilize the plusses unique to the gessoed surface—the textural differences, the ability to lift out, or to change whole areas by repainting them.

The large light shape of the falls is still of major importance, so I plan to emphasize it with surrounding darks. Instead of a distant hill to accent the top of the falls, I will substitute a dark line of trees. The foam at the base of the falls is easily handled in the gesso manner, since it can be wiped out with a small cosmetic sponge or lifted out with a brush.

I can indicate more description in the rock and ground areas by lifting out additional lights, and accenting the plane changes. Water activity and excitement is obtained by the addition of calligraphy and directional plane description.

The water shape is important to the overall design, so I make it the focal point of the picture. Movement in this water is suggested by the surface lines, the accents at the top of the falls, and the small protruding rocks in the water.

The tree line implies distance, and emphasizes the top of the upper falls. Perspective is created by the increasing measure of the waterfall in its descent and the gradation of value in the land areas.

To avoid monotony in the long passage of the lower falls, interest is provided by the small rock forms and the vertical lines of division.

the value sketch

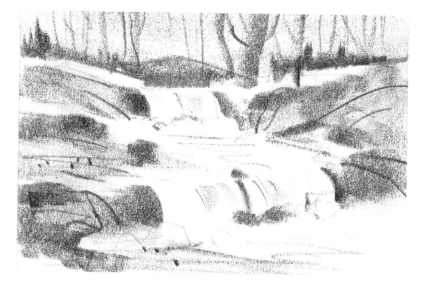

The abrupt plane change at the crest of the waterfall is the most significant area of this picture. Use the flow to describe movement and direction. Vary the value intensity to provide interest and to hold the viewer's attention on the falls.

All of the design and compositional decisions made in the photo analysis and value sketch are followed in the final gesso rendering; *i.e.,* the major light shape of the water, with its form and flow description, and the calligraphy in the foam. All of these are similar to the traditional style.

However, the textural effects obtained by the atomized water spray and the lifting by the application of a dry tissue produce an altogether different result. The texture of the linen finish Hypro paper, plus the heavier pigmentation, results in a painting that resembles an oil or acrylic more than it does a watercolor.

The palette, similar to the one used in the traditional method, was altered in the top third of the painting. An overwash of thalo blue totally changed the mood of the painting and created the effect of twilight. This forced the eye to the lower two-thirds of the painting, thereby accenting the large light shape.

the completed painting

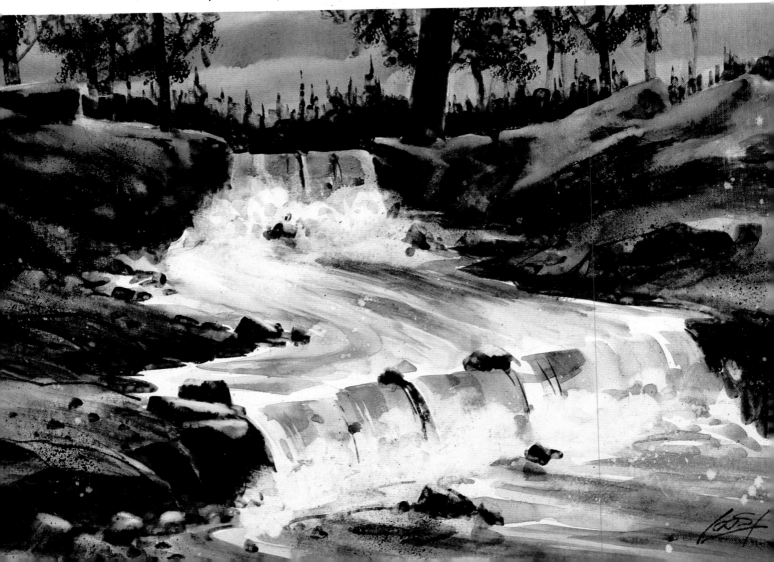

exhibit

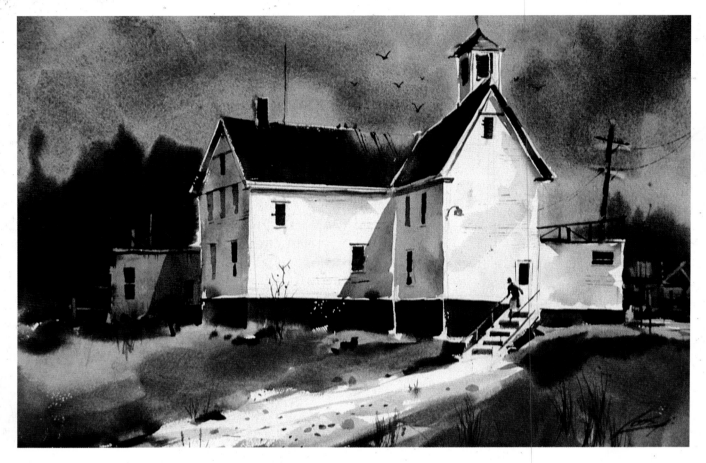

Maine Market—*22 x 15 inches,* collection, the artist.
This local grocery in Tenants Harbor, Maine, lit by the afternoon sun, has an interesting shape made even more so by the cast shadows. The yellow sunlit side affords a warm contrast to the lavenders in the shadows. The larger forms are enhanced by the calligraphic "lace", in the telephone pole, the windows, steps, chimney and the textured pieces in the warm brown background.

Maine Market II—*22 x 15 inches*
The same subject as above, but with a more spontaneous and colorful treatment. All the basic elements are retained but distorted with a casual approach. Whereas the drawing is accented in the traditional method, there is some deliberate distortion used to enhance the interest in the old building.

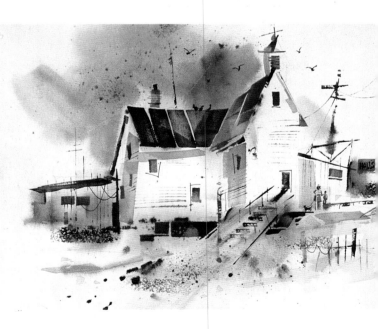

Hunk's Dory—*29 x 22 inches,* collection, the artist. Boats are of a special interest to me, and this one even more since it belonged to Tenants Harbor, Maine resident, "Hunk" Lowell, a friend and neighbor who has since passed on. The thrust of the boat is countered by the blue and red buoy. The gull, added to the composition, shows a two-way movement, with the body facing right and the head, left. The boat direction is contained by the strong horizontals in the water. The water movement was done with long, rhythmic strokes of cobalt and cerulean blue.

This diagram and those accompanying the paintings that follow, show the strong design patterns and the abstract qualities of each picture.

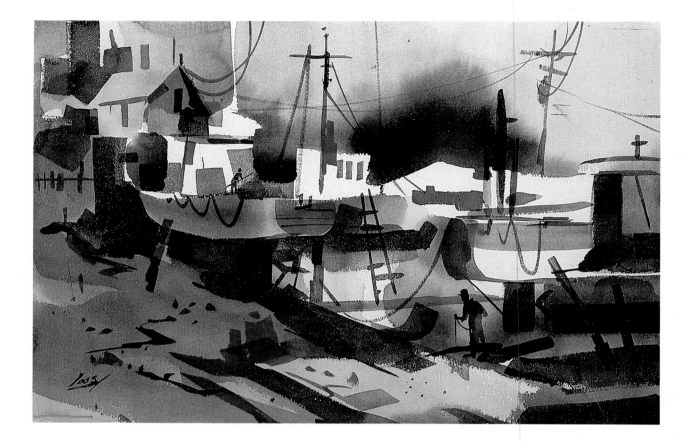

Boatyard Fantasy—*22 x 15 inches,*
This painting from Subject III, The Boatyard, is
yet another direction: impressionistic. A strong
light contained by the middle tones and darks
shows definite movement from upper left to mid-
dle right, back to bottom center right. The soft-
ness of the lost and found areas with little defini-
tion creates the impressionistic aura, with the
half-hidden figure giving life to the painting. A
minimal palette was used; gray-greens, with ac-
cents of burnt sienna.

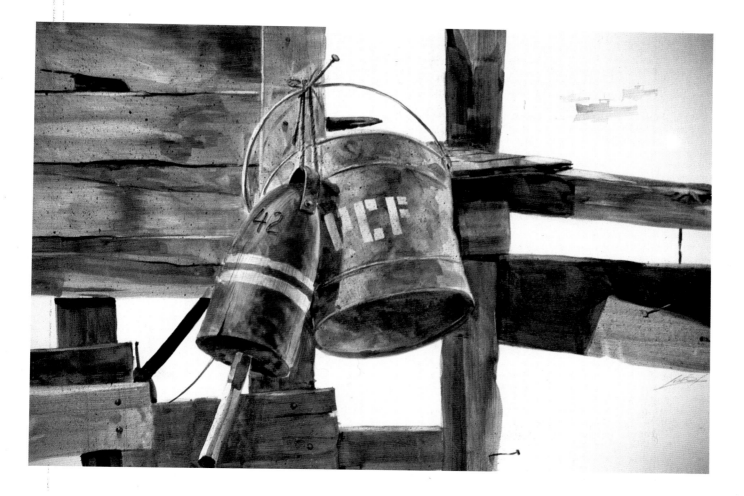

Time Worn, *22 x 15 inches,* private collection. This painting was the result of a sketch I'd made in Port Clyde, Maine. The basis was a close-up section of an old fish factory with its decaying wood creating a foreground for the harbor. Distance is suggested by the light value boat shapes at the upper right. To enliven the composition, the bucket and buoy were added. The painting was done on hot-press paper, allowing for a good variety of textures. Note the varying sizes of the light areas. Some of these were deliberately changed from the actual scene to provide more interest. Again, a minimal grayish-brown palette was used, complemented by the muted red in the buoy.

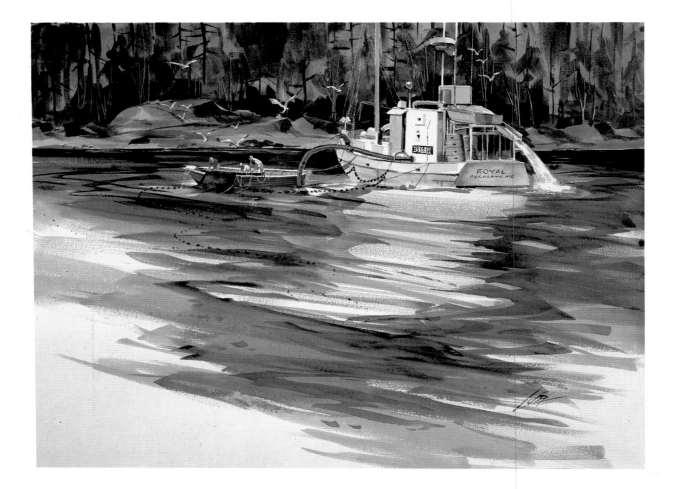

Harbor Sweep, *30 x 22 inches*
One of the many activities in South Bristol Harbor, Maine, is "sweeping" the entire harbor with nets from small boats. By pulling the nets into the "mother ship," the catch is literally vacuumed into the hold. Nothing is wasted; even the scales of the fish are used later on as a cosmetic ingredient. Considerable study was required for this work—the boat details, the net boats, floats, and the figures. The "real" background was changed from a busy dock area to a more subdued woods and rocks locale. This allowed more emphasis to be placed on the boat activity. A green dominance was used throughout with accents of bright color. 300 lb. cold-press Arches paper was used.

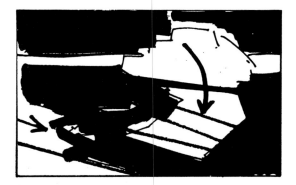

True's Boatyard *28 x 22 inches*.

A favorite painting location of mine is this boatyard in Tenants Harbor, Maine, owned by friend and neighbor True Hall. It offers so much subject material it is difficult to be selective. With the cradles, the customary equipment scattered about, and all the materials common to these areas, you must exert all the discipline you can muster to focus on the painting at hand. The three boats on their cradles provide a great change of direction in the light areas, countered by the dark, oblique perpendiculars of the cradles. The dark wooded area of deep green gives a strong contrast and a cool background to the red in the boats. The rusty oil drums, found almost everywhere, also provide a nice color accent, and the raw sienna gives warmth to the foreground. This work was painted on 300 lb. Arches cold-press paper.

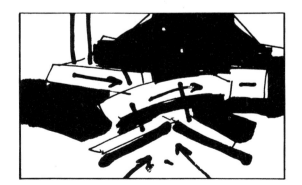

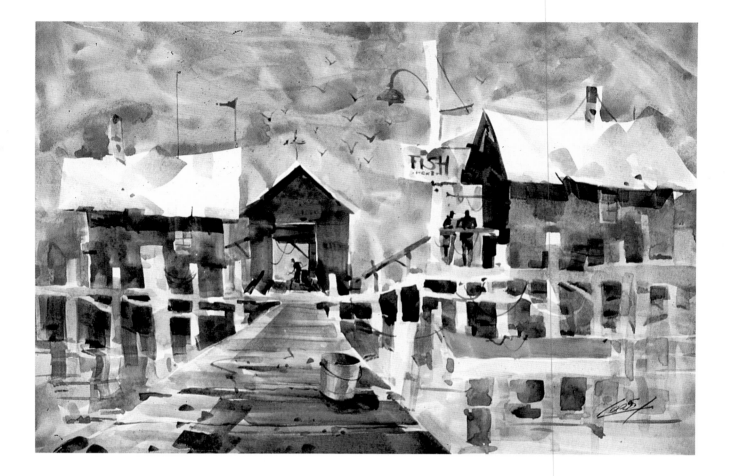

Pier Impressions *22 x 15 inches*
This painting was designed and executed strictly
from knowledge and understanding of the
subject—since no such place really exists. These
kinds of paintings I call "head arrangements"—a
term culled from my jazz music past. Painted on
the hot-press paper with emphasis on the nega-
tive and positive areas of the subject matter,
working dark against light areas, horizontals
against verticals—this was a fun painting to do.
Overwashes control the light concentration and
the sharp perspective in the dock creates the il-
lusion of depth. The figures show size relation-
ships and give action to the work. Soft muted
colors provide an overall softness to the close
value structure of the many grays.

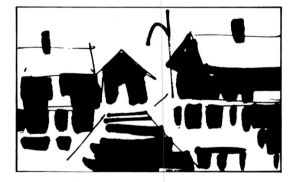

They Won't Tell *15 x 22 inches,* collection of Mary Lunsford, Cincinnati, Ohio.
Here is a successful result of an experiment in the use of Maskoid and overwashes. The daisies, creating the light pattern, were first brushed in with Maskoid. When absolutely dry, the paper was saturated with water, and the background of greens and browns was painted in with the stems and leaves executed with darker pigment. After drying, Maskoid was removed. The flower centers were then painted in. An overwash of thalo blue was quickly painted over the entire dry surface, and while still moist, the leading petals were delineated with Chinese White. This white pigment created the illusion of the third dimension as it fused in the wet areas while also softening the edges. As the paper dried, a white spatter was introduced to loosen up the finished painting.

Out of Order *15 x 22 inches*
There are times when a subject is too good to
pass up. This old lantern hanging in a black-
smith shop is a case in point. Strongly lit from
the side with a dark background, it became a
challenge for me to capture its essence. The bat-
tered old metalwork and the absence of the glass
globe—these only served to create a feeling of
more pathos. Again, the hot-press paper was
used, aiding in the development of the texture
and detail. The muted colors added to the overall
feeling of antiquity. A grayed-green was the
primary color base with warmth added
to the timbers.

Color Burst *25 x 22 inches*
Painting *florals* are more fun in some respects than painting *flowers* in great detail. Here I concentrate more on the design and the essence of the subject than on the type of flowers. This gives me greater latitude as to color and value. The explosion of red is achored by the vase and dropped blossom. The intense color of the flowers is emphasized by the grayed background and light foreground. Flowers should be colorful, soft and fresh. Watercolor is ideal for supplying these objectives.

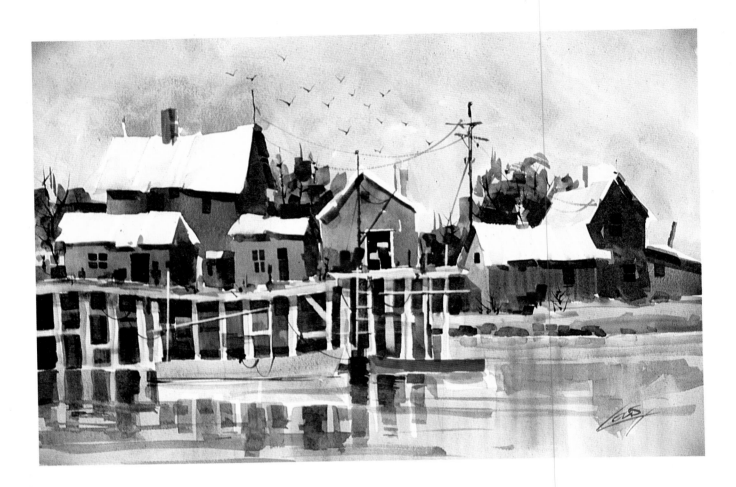

Vinalhaven Line, *22 x 15 inches,* collection Mr.
and Mrs. William Condit, Denver, Colorado.
As in *Pier Impressions,* much is made of the neg-
ative and positive relationships exhibited in this
work. Size relationships in the lights, from the
pilings to the lobster shacks, from the horizontal
to the vertical, create a spatial rhythm, modified
by the sky area. Again, the lace or calligraphy,
as in the birds, the poles, ladder and ropes, pro-
vides the "icing on the cake." The dark areas tie
the painting together, making the whole painting
work as a unified design. The blue sky is repeated
in the water which is decorated with reflections.

The Blue Door—22 x 15 inches, collection Mr. and Mrs. William Iliffe, Tenants Harbor, Maine. Architecture has always fascinated me, especially that of Maine. The sturdy, yet functional construction seems to be a "natural" for watercolors. This example, on the island of Vinalhaven, is ideal, with its severe lines. The whimsical blue door was an island of color in a sea of grays.

The painting was done on 140 lb. hot-press paper, enabling me to go into great detail in the windows, door and overall construction. The dark green lower foreground provided support for the entire picture.

The color (or lack of it), is a mixture of Davy's gray and raw umber, a combination that best describes Maine's natural look. The foreground was composed of olive green and burnt umber, with the door accented in a wash of cobalt blue. As shown in the small sketch, the design was primarily vertical with horizontal accents.

Dianne Loos

Tidal Flow Triptych—three panels, 46 x 30
inches, collection, the artist.
A multi-media approach to watercolor is shown
in this impressionistic work, where a variety of
aqueous and collage techniques were combined.
Torn pieces of rice paper were first collaged to
the Morilla paper surface. When dry, major de-
sign masses were sketched, using a close-up pho-
to of a Maine tidal pool as a stimulus. The large
gray masses were the first washes, using Davy's
gray as a warm contrast to the purples, greens
and blues of the rocks. A good relationship of
color, values and placement was kept in mind at
all times, while allowing the rhythmic and free
flow of shapes to occur at will. The appearance
of depth is not only facilitated by the well-placed
darks, but by various absorbencies of rice paper,
and the resist effect from the acrylic medium
used between layers. Using both the rigger brush
and dagger striper with white ink, the rhythmic
water flow was added last, using some rice
paper for build-up. The impression of flowing
water was further accented by the trip it makes
through three different sized panels, each framed
separately and hung an inch apart. The feeling
of flowing water is further emphasized by the
trip that the viewer's eye takes when moving
from panel to panel.

AUTHORS NOTE: I felt it would be
informative and interesting to include
work that my wife Dianne has done.
She uses an altogether different ap-
proach to watercolor, a more spontan-
eous or "go with the flow" experience,
using rocks and rock formations as her
subject matter in these two paintings.
She already is an accomplished tradi-
tional painter, but is constantly
reaching out in new directions as may
be seen in these unusual and beautiful
paintings.

Dianne Loos

Balancing Act, *30 x 22 inches,* collection, the artist.
This collage began as a large felt-tip sketch done
on location at a quarry in Tenants Harbor,
Maine. Fascinated by the juxtaposition of rocks
in their natural state, the artist has interpreted
them most creatively in this unusual abstract
composition. Rock shapes were torn from pre-
viously textured sheets of Morilla paper, then
collaged onto the design, utilizing strongly paint-
ed directional lines and areas of light and
midtone. The stark flat sky of opaque dark
brown ink offers an excellent contrast to the
varied earth-tone layers of light and textured
rocks, giving added dimension and depth. Nu-
merous tools ranging from brushes to brayers,
toothbrush and striping wheel, *Saran* wrap and
salt, were utilized in the execution of this work.
This painting was selected for the 1984 Louisiana
Watercolor Society's 14th Annual International
Exhibit in New Orleans, Louisiana.

a few thoughts about matting . . . and framing

The following comments reflect my opinions concerning the matting of watercolors. They are not absolutes, but they seem to agree with the opinions of many other professionals. In the matter of color, it is my contention that brightly colored mats or dark mats tend to decrease the effectiveness of the work by overpowering it. Subtle-colored liners may be used, although I prefer a white liner with an outer mat of neutral gray or grayed pastel. Regarding mat width for one-quarter and one-half sheet paintings, I prefer a two and three-quarter inch outer mat with a one-quarter inch liner for a total width of three inches. Whatever the mat dimensions, I prefer the professional look of a mat cut with a beveled edge.

Some artists prefer the bottom section of a mat to be wider than the other three, however, a mat of equal dimensions is equally suited for horizontal or vertical use. Full-sheet paintings require a larger mat, thus a 3½ or 4 inch mat is the best overall width.

Outer dimensions for one-half sheet paintings are 27 x 20 inches; full-sheets are 37 x 29 inches.

In the past few years I have found the new metallic liners to be effective for many reasons. They are elegant-looking when combined with the same color metal frame, and have a longer life than an ordinary mat liner. When weight is a concern, a metal liner is much lighter than a mat, and eliminates the need for a double mat. The cutting of these liners requires much the same accuracy and neatness needed in chopping and assembling wood frames.

Many mat cutters are available—from the economical to the expensive—for the *do-it-yourselfers*. Depending upon your skills, space, quantities required, and of course, cost—the choice is yours. Do it yourself, or have a professional do it, but choose and assemble your mats carefully. If you see the mat first, then *you have over-matted*.

Framing a watercolor is equally as important as matting. In fact, the two must be well-coordinated for a professional-looking job. With so many styles, finishes and materials available today, it is easy to be confused about which type to choose.

My *first* considerations are the painting type (abstract, realistic etc.) and the subject matter. Then in what type of setting or decor is it going to be displayed, and will the painting be hand-delivered or shipped? In all cases, the frame should never overpower or dominate the painting in size, color, or style. I stay away from the ornate, baroque styles which are better suited to oils and acrylics. The frame and mat on a watercolor should provide a neutral support to the artwork. Remember, if you see the mat or frame first, something's wrong!

For local exhibitions and one-man shows I prefer the many custom frames available in wood. I usually choose a simple, yet well-proportioned frame, with perhaps a touch of gold or silver. Again, simplicity is the key to good taste. Many of my New England seacoast subjects lend themselves to barnwood frames, as do rural farm and woods scenes and other rustic paintings.

Because of their economy, weight, and simplicity, metal framing sections offer the ideal solution when paintings must be shipped. I prefer the deeper style 1½ inch frames because their depth gives added substance and richness to a painting, and is an excellent proportion for half-sheet and full-sheet watercolors. By substituting *Plexiglas* for glass (or for added economy, stormdoor replacement acrylic), shipping requirement are met, and weight is substantially reduced.

As I am constantly unmatting and unframing paintings for travel and workshops, it is not cost-efficient for me to use museum mounting and framing methods for most of my framing need. However, for permanent framing, I strongly recommend these museum methods, all PH neutral materials. One of the acid-free materials I use consistently is the foamcore, which I find is an excellent backing for all matted and/or framed artwork. It is equally suitable as a mounting board when using pressure sensitive adhesive or mounting paste.

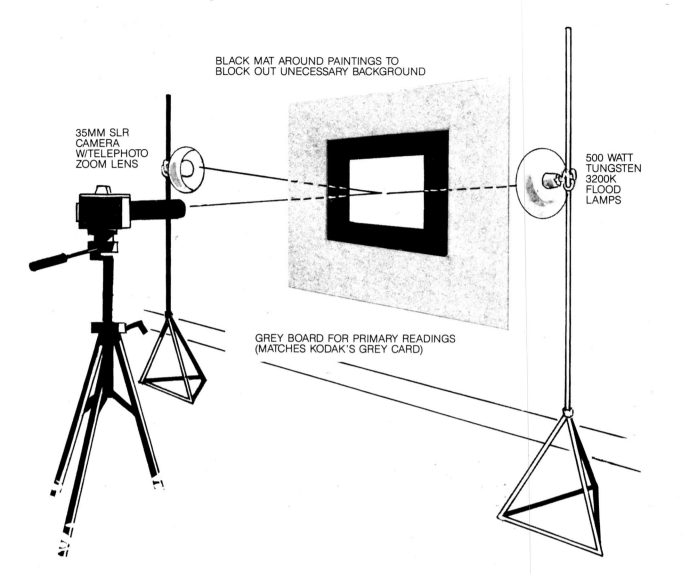

BLACK MAT AROUND PAINTINGS TO
BLOCK OUT UNECESSARY BACKGROUND

35MM SLR
CAMERA
W/TELEPHOTO
ZOOM LENS

500 WATT
TUNGSTEN
3200K
FLOOD
LAMPS

GREY BOARD FOR PRIMARY READINGS
(MATCHES KODAK'S GREY CARD)

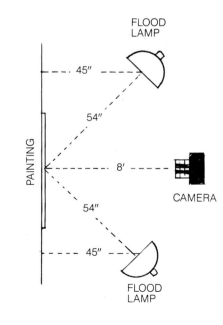

FLOOD
LAMP

45"

54"

PAINTING

8'

CAMERA

54"

45"

FLOOD
LAMP

photographing your paintings

Being able to produce quality 35mm slides of
your paintings is recommended if you wish to
keep track of your work which may be with
galleries, agents, collections, etc., and if you
intend to enter juried competitions through-
out the year. Having a professional photog-
rapher photograph your work is an option,
but a costly one. I prefer to do my own
photography, using the indoor set-up. It is
portable and the results are always high
quality.

The equipment I use is a Konica T3
Autoreflex 35mm camera, a Vivitar telephoto
lens (85-205mm), a sturdy tripod, two metal
telescoping lightstands, two clip-on reflectors
with 500-watt tungsten bulbs (3200K), a
sturdy background board (3x4 feet fiber-
board), a half-sheet and full-sheet mat of
black (which eliminates the need for

words worth consideration

In retrospect, and in re-examining what I have written, and the watercolors I have painted, several important facts stand out—the use of the value sketch, the insistence on good design concepts, the relationships of size, shape, value and color—all of these point to the importance of planning a painting before actually rendering it because no matter what direction you take, as an artist, these facts, put into practice, can aid in producing a quality work of art.

Given these truths, you, as a painter, should grow in your abilities and your perceptions. Remember that it is the creative mind that produces work that both excites and stimulates. Every painting is a challenge, and to face that challenge you need all the ammunition you can have at your disposal. It is a great joy to face up to and solve the problems along the way. Perhaps this is one of the reasons that artists are *what they are*. Where one's *self* is the strongest competition, it is most gratifying to win.

The "spiral of learning" teaches us that the more we know, the more we realize we *don't* know, and that the pace of adding to our appreciation and understanding far outstrips our capacity to enhance our abilities. This should provide the impetus to drive ourselves to greater heights in our chosen work.

You will suffer failures and disappointments along the way but you will also profit from them. This is all part of the craft that you are involved in. The knowledge gained, your increased understanding and abilities, make all your efforts worthwhile.

I hope that with this book, you will gain not only knowledge, understanding, and a wider appreciation of the many ways of self-expression in watercolor, but the actual skills needed to reach these goals.

masking out on the slide), and pushpins or tacks for attaching art to the board. A zoom lens is suggested when photographing several sizes of paintings, since it enables you to keep your tripod in the same location, thus making the results more consistent, while saving time and effort.

Kodak 160 Tungsten Ektachrome slide film is my favorite, with a setting of F11 at 1/30 consistently reproducing the whitest whites and truest and strongest colors of my paintings. This setting resulted from much experimentation with settings, exposures, and bracketing both ways (F11 at 1/15 and 1/60, F8.5 and F16 at 1/30 for example). Make sure all room or overhead lights are turned off when photographing. (The sketches illustrate the arrangement and distances I recommend for your equipment.)

glossary of terms

Dynamic Shape—one that suggests energy or movement

Form description—effecting the appearance of third dimension by varying values in flat forms.

Good Shape—two different dimensions, oblique, and with interlocking edges.

Interplay—the reciprocal action between lines, shapes, colors and values

Lineal Definition—the describing of a form, direction or object by use of line only.

Negative shape—the optical space between positive shapes.

Oblique/Diagonal—line or form that is neither vertical or horizontal.

Overwash—a transparent wash used to alter the coloration of a previous wash.

Plane change accent—the optically darker accent that occurs as form turns away from the light.

Relationship—the apparent difference between form or line by either shape, value, color or size.

Space Division—the breaking up of areas into a pleasing arrangement of different size shapes.

Static Shape—one that is motionless in appearance or at rest.

Symbolism—the simplification of an object ot its barest identifiable form.

Underwash—an initial transparent wash used to support and unify the painting.

Up-plane—the upper surface of an object or form that receives the light.

Value scale—a graphic chart showing values from one (white) to ten (black) in a graduated scale.

Vignette—a design or painting utilizing areas of the untouched paper (usually in corners and along edges) as part of the composition.